CHATHAM
THROUGH TIME
Philip MacDougall

AMBERLEY PUBLISHING

First published 2011

Amberley Publishing
Cirencester Road, Chalford,
Stroud, Gloucestershire, GL6 8PE

www.amberley-books.com

Copyright © Philip MacDougall, 2011

The right of Philip MacDougall to be identified
as the Author of this work has been asserted in
accordance with the Copyrights, Designs and
Patents Act 1988.

ISBN 978 1 84868 635 9

British Library Cataloguing in Publication Data.
A catalogue record for this book is available from
the British Library.

Typeset in 9.5pt on 12pt Celeste.
Typesetting by Amberley Publishing.
Printed in the UK.

Introduction

Chatham, as of 2011, is in the midst of transition. With a £1 billion regeneration project gradually reaching completion, the town has already seen the introduction of a drastically revamped road system and bus station (the latter misleadingly named *Waterfront*) with an expanded shopping area also included within the plan. Nothing like it has been seen in Chatham since the construction of the Pentagon (with its own collection of any town shops, heavily polluted bus station and gloomy multi-storey car park) that emerged from a similar rebuilding of the town centre in the early 1970s.

To be honest, Chatham has been in the middle of some kind of transition for the last sixty or seventy years, or even a great deal longer. Most of the illustrations in this book are a reflection of those numerous (and often major) changes that have befallen Chatham throughout much of the twentieth century. Rarely, so it would seem, unless time is traced back to those early days when Chatham was a mere fishing village, is it possible to detect a time of sufficient length that permitted an extended period of quiet adjustment.

At the heart of this constant need to adjust, is that of the town now being a defunct military-industrial complex. Initially developed as a naval town during the late sixteenth and early seventeenth centuries, Chatham really only thrived during times of war or threatened war. In contrast, and during times of prolonged peace, the town witnessed not boom but bust. In the dockyard, the *raison d'être* for the very existence of the expanding town, hundreds of artisans and labourers would either be laid off or placed on short time. In turn, the various support facilities that had followed on the heels of the dockyard, among them a naval ordnance complex, a range of fortifications and military barracks with naval and marine hospitals, were also reduced in usage, leading to further lay-offs and reductions. This, of course, was not the end of the story, with fewer in employment and less money floating around, town traders also suffered, adding to that general aura of depression.

Yet, the mid to late-twentieth century, unlike those earlier years, took the process one huge and irredeemable step further. Instead of imposing lay-offs upon those employed within the various naval facilities, it was decided that the entire military-industrial complex, lock, stock and barrel, should be totally annihilated. Admittedly, it took several decades to achieve, beginning with immediate post-war retrenchment it continued into the 1950s with the closure of the Royal Marine Barracks (Dock Road) and was not finally completed until 1984 when both the dockyard and adjoining naval barracks were closed.

While the initial attack on the Chatham military-industrial complex was survivable, the ultimate indignity, the closure of the world-renowned dockyard, was nothing less than a cataclysmic disaster. The area's single largest employer, the dockyard was, quite simply, Chatham. While grandiose plans were created for the development and transformation of those areas abandoned by the navy, it took a good many years before any of them reached fruition. In the meantime, those once employed in the yard had either to face long-term unemployment or move themselves and their families to where alternative work existed.

So, this long-term transitional period has seen Chatham enter into a new age. Formerly a military-industrial complex hemmed in by tightly packed housing that had been built for those employed within the complex, the town has now become something that is very different. But exactly what the town has become is extremely difficult to fathom. Inconsistencies in planning have helped create a cloud of confusion. In the 1980s, the emphasis was very much upon making post-closure Chatham exclusively a business centre with nothing placed in the way of providing accommodation for new enterprises or small businesses that expressed an interest in moving to the town. Anything historical, and which might threaten this process, was simply bulldozed and obliterated. Only the Georgian portion of the dockyard, thanks to a miserly £24m government start-up grant, was sacrosanct. In a brief philistine period, attractive buildings of age were removed and replaced either by a hideous new road system or less attractive buildings of modern brick.

The current period of transition is a clear admission that much that was inflicted upon Chatham during the final years of the twentieth century was, quite simply, inappropriate. Why else is there now a complete gutting of the town centre? Included in this latest attempt at regeneration is the removal of a flyover, opened in 1995, that effectively destroyed the west end of the High Street by simply cutting it off from the rest of the town. Even more bizarre, although strangely logical, is that the town, which was once in denial of its heritage, has suddenly put together a package that will hopefully result in it achieving world heritage status in 2012. Central to this, of course, is the Georgian period dockyard, Fort Amherst and the former site (through the development of a partial riverside walk) of the naval ordnance complex and the Royal Marine Barracks. Obviously, some attention still needs to be given to the outer envelope, the peripherals of the town reflecting a period of neglect that, in itself, is as historical as many of those buildings that have been relabelled as world heritage contenders.

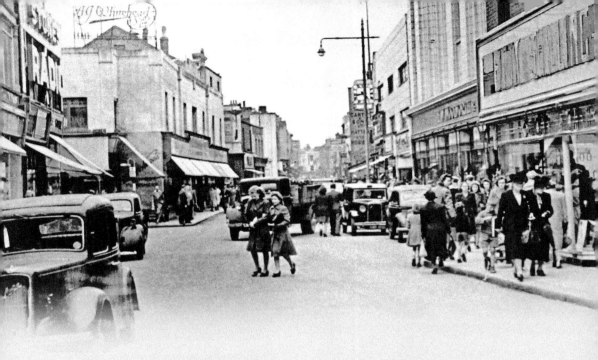

CHAPTER 1

The Town Centre

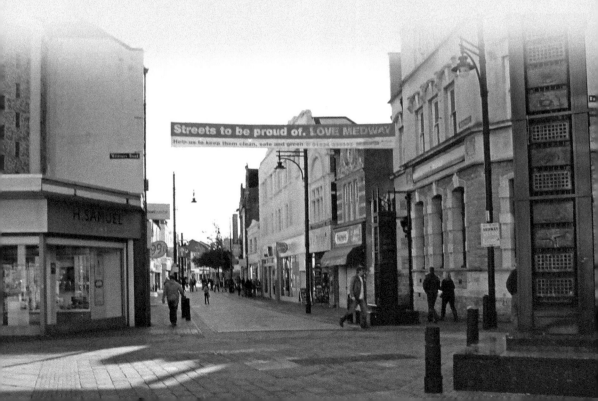

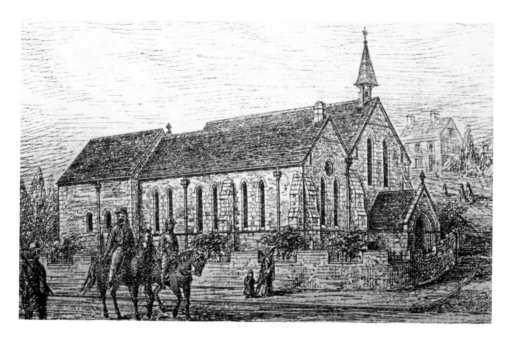

St Bartholomew's Chapel

Marking the entrance into Chatham from Rochester is St Bartholomew's Hospital Chapel. A medieval building in origin, but heavily restored by Sir Gilbert Scott during the nineteenth century, it was part of the original St Bartholomew's Hospital that had been established in 1078 for those suffering from leprosy. Its current state does little to enhance Chatham, as a centre for tourism, while its future is currently uncertain.

Previous page: two contrasting views of the central section of the High Street with the earlier photograph dating to the late 1940s when the area was both unpedestrianised and possessed a Woolworths!

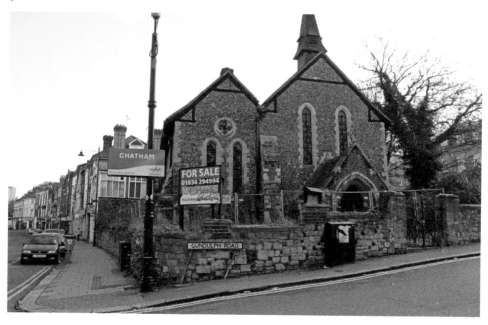

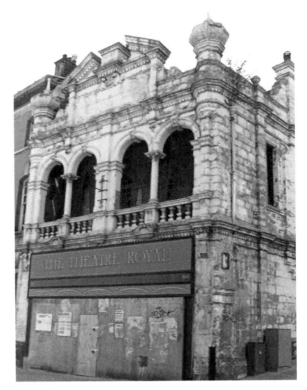

Two Buildings facing Demolition
The Barnard family of Chatham were big in the world of entertainment, members of the family founding the Palace of Varieties, which at one time occupied Nos. 107-11 at the west end of the High Street. This was a music hall that succumbed to a serious fire in March 1934. The demolition of this building is the subject of the earlier photograph. Almost opposite the Palace of Varieties the Barnard family also financed the building of the more up-market Theatre Royal. Built in 1899, it continued to put on performances until the mid-1950s when it was converted into shopping space. A magnificent building, and one that was well worth preserving, efforts to achieve this now appear to have failed, with this building also on the verge of demolition. Given that the west end of the High Street had, at one time, a strong Victorian character, it seems most unfortunate that buildings of such merit are continuing to be sacrificed to the needs of modernity.

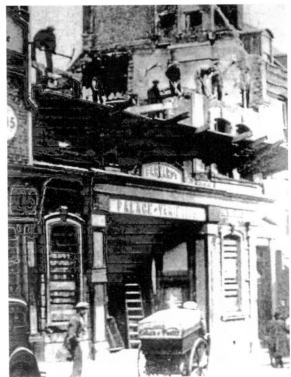

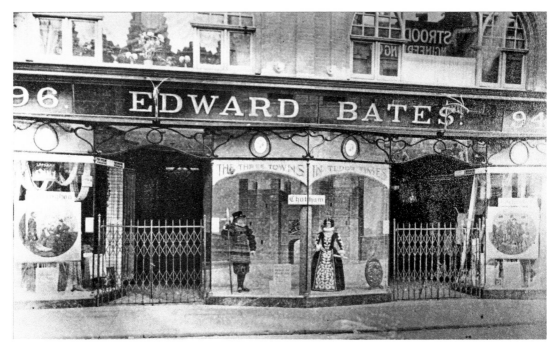

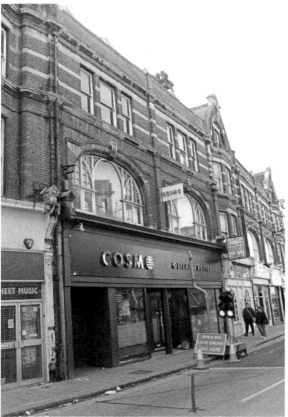

Edward Bates

Edward Bates was a draper that was also located at the west end of the High Street (No. 94-6) at a time when this was a lively and fashionable area. By the 1960s, Edward Bates had diversified into furnishing, fashion and children's wear. Today it is the location of the Cosmo Oriental Buffet, a Chinese restaurant.

The Shopping Experience

Chatham, in having lost its major employer, the naval dockyard, has gradually shifted its economic centre of gravity towards the accumulation of retail outlets. The High Street, supported by numerous corner shops, was once the full extent of the experience. The Pentagon proved the first in-road to the new-style shopping experience followed by the emergence of several expansive supermarkets. Most recently, through the reuse of a dockyard industrial building that allowed for the creation of Dockside (see page 89) the number of retail outlets in the area has dramatically changed. To provide a flavour of how shopping was once conducted, the BBC brought their hands-on 1930s shop to the Pentagon in November 2010 while the earlier photograph is an interior view of Edward Bates' department store as seen on 13 June 1908.

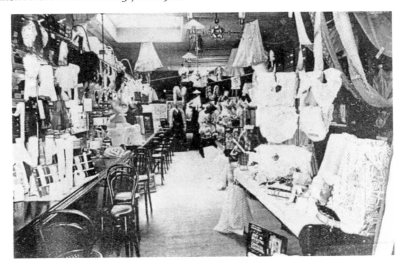

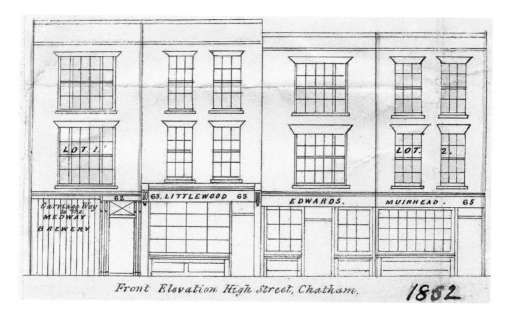

Front Elevation High Street, Chatham.

1862

High Street (West End)

A drawing of 1862 showing a group of shops at the west end of the High Street (consecutively numbered as 62-5) that was, at that time, under sale. The subsequent renumbering and removal of properties in this area makes it difficult to identify the precise buildings, but there can be little doubt that the group shown (Nos. 63-7) are distinctly similar in style.

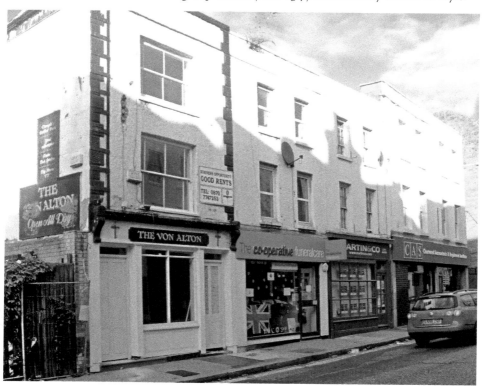

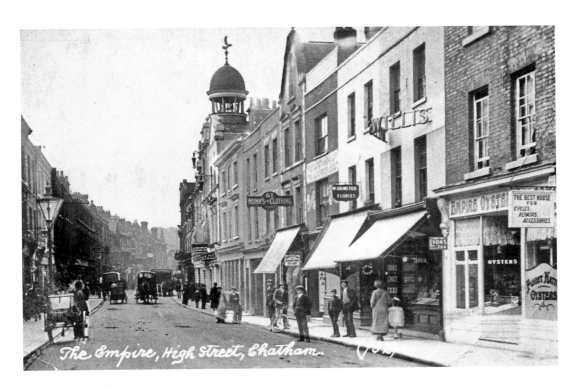

The Empire, High Street, Chatham.

Empire Theatre

The domed building is the Empire of Varieties that was both a cinema and music hall. Nowadays Anchorage House, the Medway County Court, occupies this same site. All that survives of the Empire is a cut down part of the original boundary wall (see inset). Other buildings that once occupied the High Street in this area are the Empire Oyster Bar (No. 69), S. E. Wills, a photographer (No. 67), M. Brimstead, florists (No. 65) and Nunns, a clothes shop (No. 63). A similarly eclectic collection of shops is still to be found in this part of the High Street.

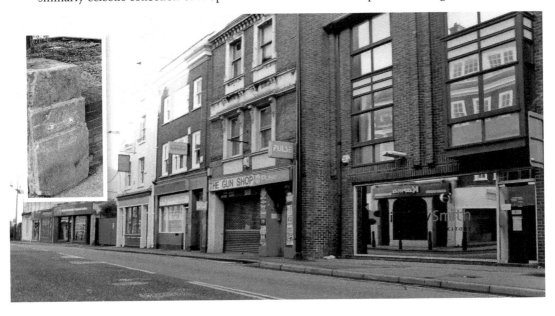

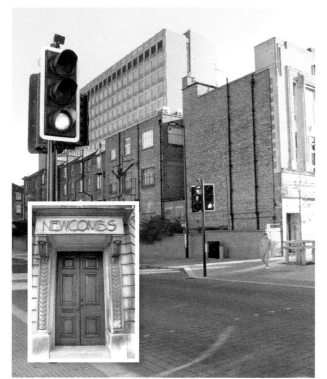

Globe Lane

For just over 150 years F. & H. Newcomb Ltd, one of the oldest High Street retailers, had their premises on the corner of Globe Lane and the High Street (No. 133). However, the building of the Chatham ring road in the mid 1980s resulted in this shop (see lower photograph) being demolished for construction of the Sir John Hawkins flyover. In turn, the flyover has itself been demolished and replaced by a low level road. Newcomb's was subsequently re-established in a new shop close to Medway Street (see inset). At one time F. & H. Newcomb had a factory in Globe Lane for the manufacture of shirts while one of their most famous customers was the novelist Charles Dickens.

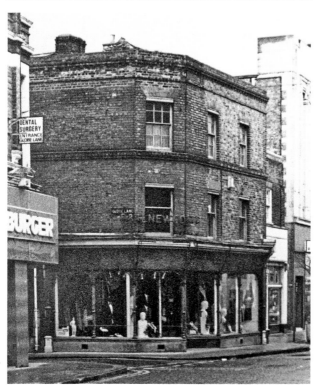

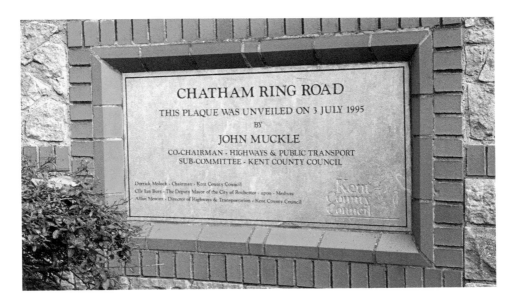

Sir John Hawkins Flyover

The dream, as represented by the artist's impression of what supposedly was to be, was that the Sir John Hawkins flyover, once completed, would actually enhance the west end of the High Street. Planned in the mid 1980s, and constructed as part of the new ring road, it brought not prosperity, but decline to an area that had already been suffering since the opening of the Pentagon some twenty years earlier. Even those shops that had stalwartly remained, now found themselves under threat as fewer and fewer shoppers chose to go outside the concrete collar that now surrounded the town. In July 2009 the flyover, which had actually been named after an Elizabethan slave trader, was demolished. With a low level road replacing the flyover, this part of the High Street still remains effectively cut off from the rest of the town. As for the plaque that celebrates the opening of the ring road in July 1995, this is located on the north side of the Paddock.

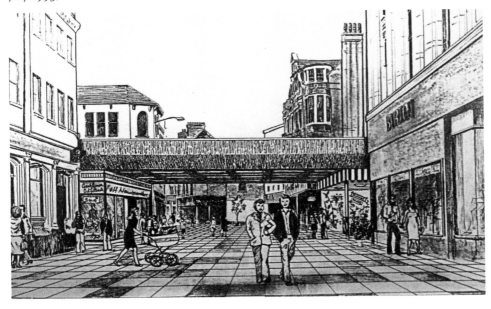

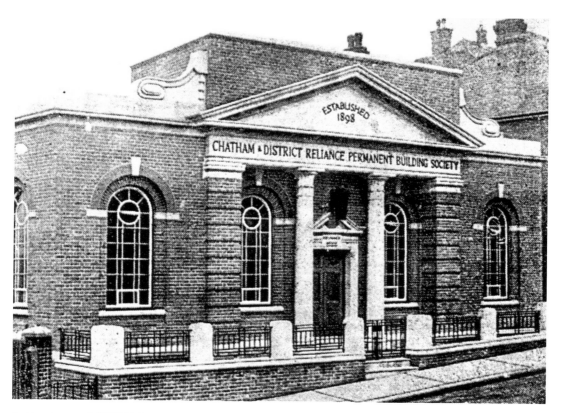

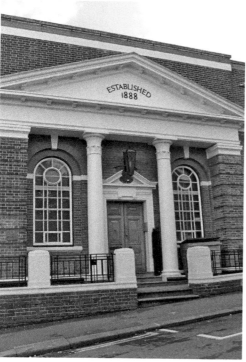

Manor Road

Originally the head office of the Chatham Reliance Permanent Building Society, this property is in Manor Road. The earlier picture was taken shortly after completion of the building in 1933. In more recent years, the Chatham Reliance amalgamated with the Kent Reliance Building Society, a fact that explains why the year of establishment differs in the two photographs. In the earlier picture, the year 1898 is given, this being the date when former mayor of Chatham, H. Paine, helped found the society. However, with the building having fallen into the hands of the Kent Reliance, a society with the earlier founding date of 1888, the establishment year was duly changed. The building is of the mock-Georgian style and was designed to allow for the possible addition of an upper floor. It was constructed at a cost of £5,000.

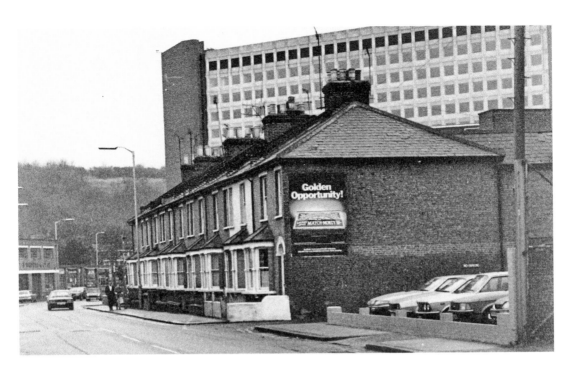

Medway Street

Nowadays Medway Street lacks any residential properties and offers only a through road that hosts a car sales room and a large office supply company. This seems unfortunate for such a centrally located road that could have seen more favourable development over the years. The residences, which were demolished in 1987, had once been owned by Edward Bates' High Street store, used by staff that were employed in altering clothing. Beyond, of course, is Mountbatten House, erected in the mid 1970s and is a feature that appears in both photographs.

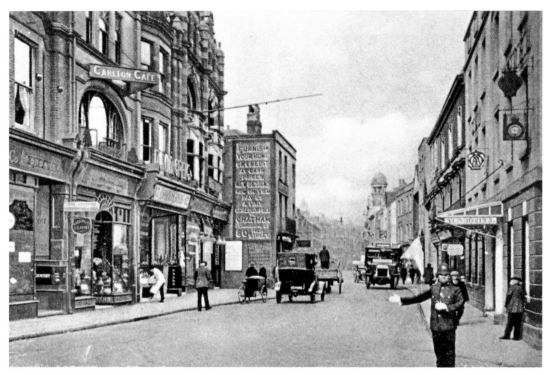

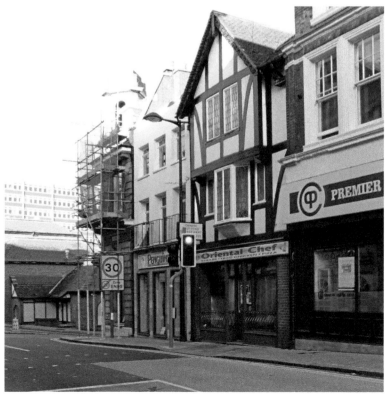

Sun Hotel

Situated at the east end of Chatham High Street, the Sun Hotel (85 High Street) was once the town's leading hotel, described in the 1920s as a 'first class family, commercial, naval and military hotel' that had garaging for cars and, in catering for the prejudices of the time, an 'entirely English staff'. The same site today, on the corner of Medway Street, houses a building that dates to the 1980s.

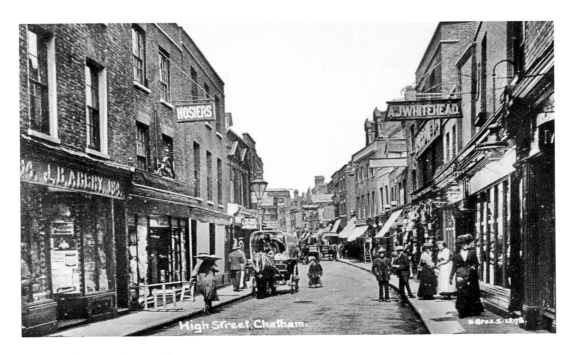

High Street (East End)

In the earlier picture, and mid-way along the right hand side, can be seen a sign which declares the way 'to the Long Bar'. This represents the entrance to the former United Services Pub and which had a bar that stretched, 'wild west fashion', from front to rear. Fights between different branches of the armed services were quite common, with the Military Provost invariably keeping a close eye on the premises. Within the Pentagon, which has one of its main entrances close to this same point in the modern-day High Street, Emily Lloyd of Delumptions offers locally produced confectionary for parties and weddings.

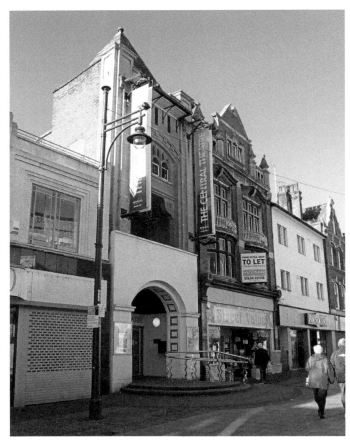

Central Hall
First opened in March 1908
as a Wesleyan Mission
and with a remit to
provide entertainment in
surroundings free of alcohol,
the Wesleyan Central Hall
was acquired by Chatham
Borough Council during the
late 1960s. It now serves as
a popular local theatre that
has staged everything from
pop concerts and ballet
through to the traditional
Christmas pantomime.

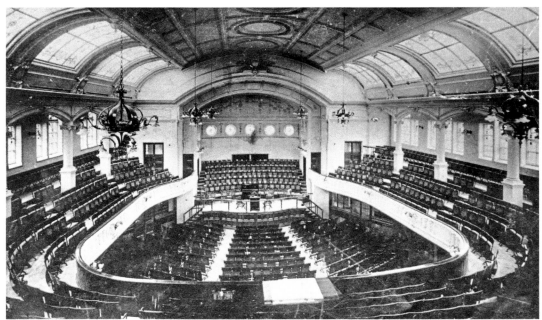

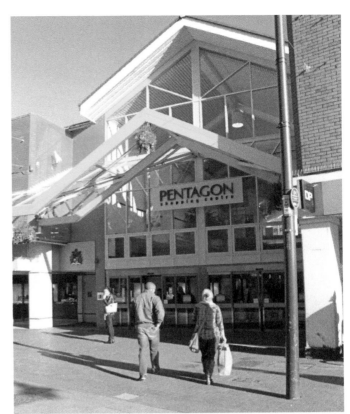

High Street (Mid Section)
The section of the High Street between Military Road and the Brook has, over the years, seen some fairly dramatic changes. One of the oldest buildings to survive into the twentieth century ended its life as Platform 9. Its age is fairly indeterminate but would have contributed to the more recent desire on the part of Medway Council to become a World Heritage Centre.

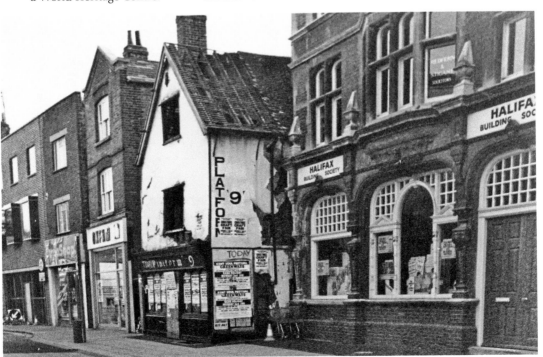

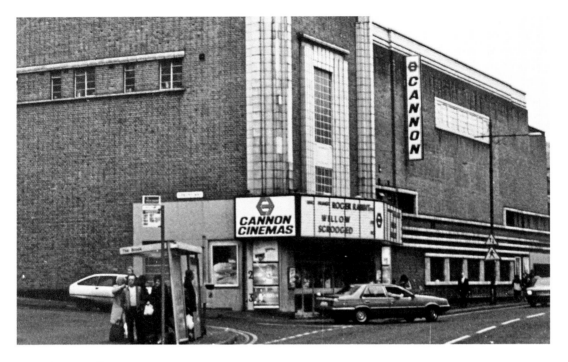

Cannon Cinema

For a brief period in the late 1980s, Chatham's first super cinema, opened as the Super Regent in July 1938, was in the hands of Cannon Cinemas. However, despite its long history, an ageing cinema in this part of Chatham was incapable of competing with the multiplexes and was eventually forced to close, being superseded by an entirely new structure (Pembroke Court) on an extensive site that runs back from the High Street and along much of the length of Upbury Way.

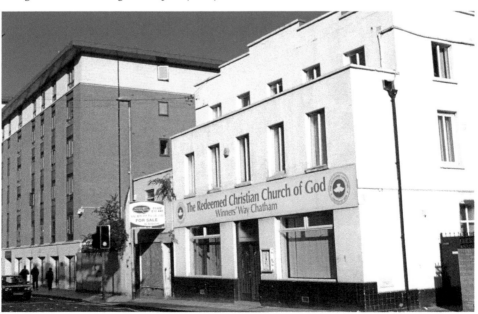

Brook/High Street Intersection

The area of the High Street where it joins
the Brook little resembles how it looked
during much of the twentieth century.
A particular focal point in this area, at least
from 1937 onwards, was the Ritz cinema
building. In later years it was to play out
its life as a bingo and social club before
destruction by fire in September 1998.
A reminder of what this area of Chatham
might once have looked like is preserved
in the architecture of the White Lion, a
building in the High Victorian style.

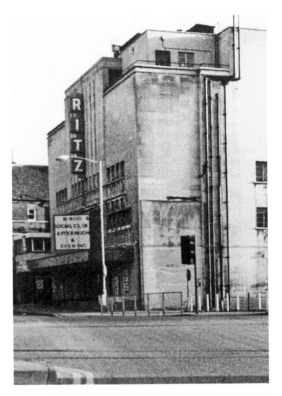

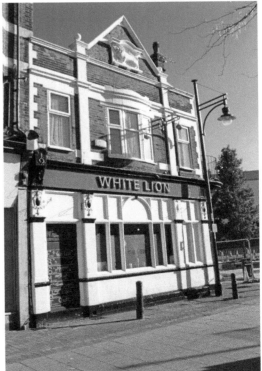

Danger! Demolition in Progress
An example of how Chatham, over the years, has seen the removal of some of its finer buildings, these often to make way for more roads. Here, in the earlier photograph, a number of buildings have been removed at a point close to Luton Arches. Of significance however, is that a fine late-Victorian building (far left), the former town library, is also about to undergo a similar fate.

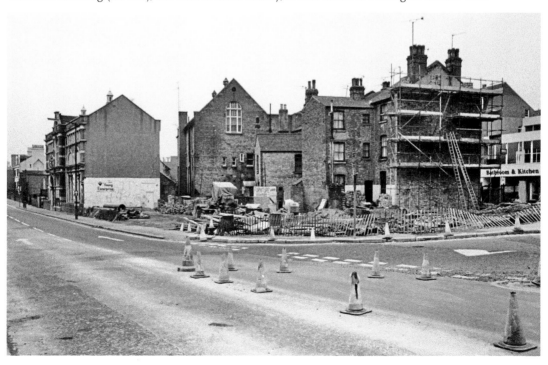

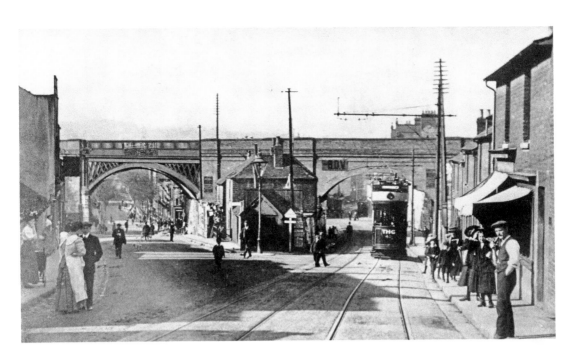

Luton Arches

Two views taken from more or less an identical position but separated by a hundred years. Always busy with traffic, this area is now dominated by cars and a solitary speed camera where once the tramlines of the Chatham & District Light Railway Company were once embedded. The arches date to 1860 and were originally built for the trains of the London, Chatham & Dover Railway Company.

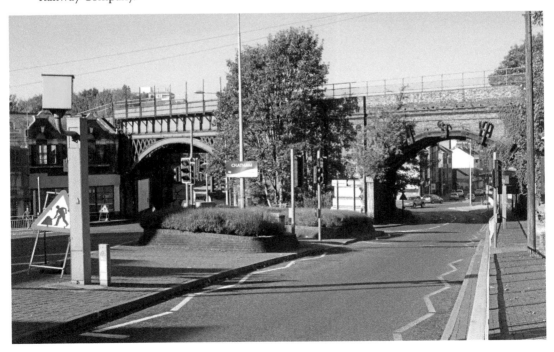

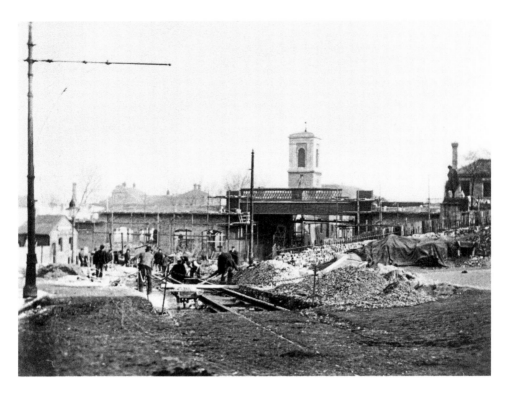

New Road Viaduct

The earlier photograph shows the laying down of rail lines for the new tramway system that was officially opened in June 1902. The viaduct bridge that can be seen behind had only just been completed. An earlier, brick built viaduct, which had provided only limited space to pass through, had been built in 1779/80 but had to be rebuilt to permit both sufficient height and width for tram cars.

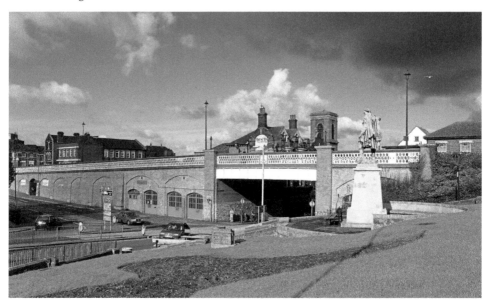

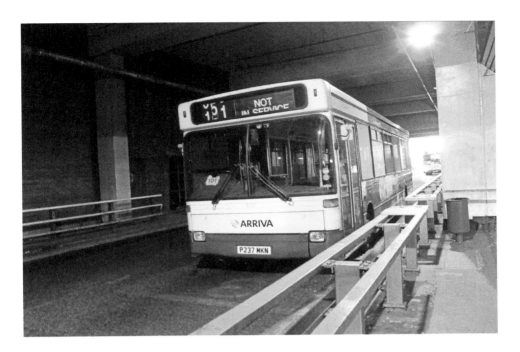

Trams and Buses

The tram interchange in Chatham was outside the Town Hall, with this example of a Chatham & District Light Railway Company car about to move off in the general direction of Luton. It was only with the introduction of the Pentagon, that an enclosed area for public road transport was introduced into Chatham. However, the Pentagon bus station, from its inception, met many complaints due to a build-up of fumes. A new bus station is now under construction in Globe Lane, this to replace the one in the Pentagon.

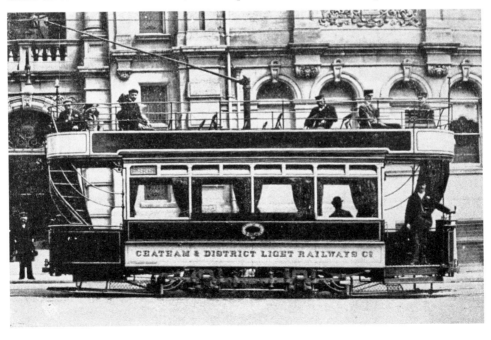

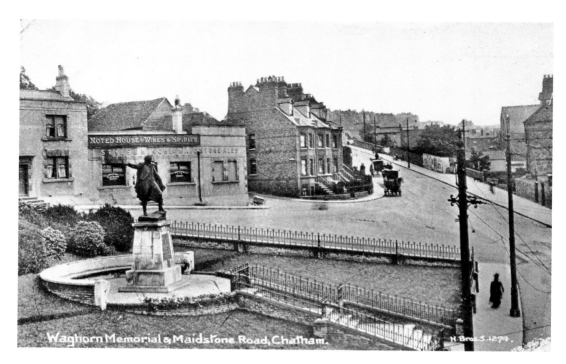

Waghorn Memorial & Maidstone Road, Chatham.

Maidstone Road

The focal point of both photographs (old and new) is the Waghorn memorial that lies close to the viaduct. Waghorn himself pioneered the overland route to India and had strong Chatham connections. Unusually, this area has changed very little, other than the nature of traffic and, around the grassed area, the brick wall that has replaced the earlier iron railings.

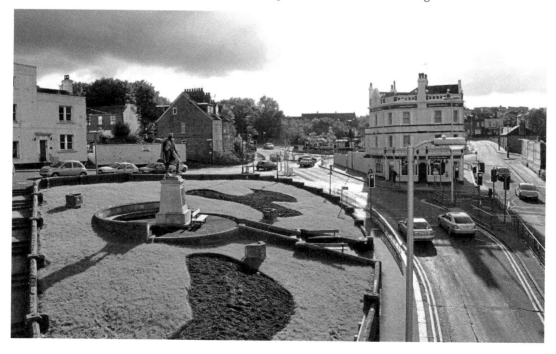

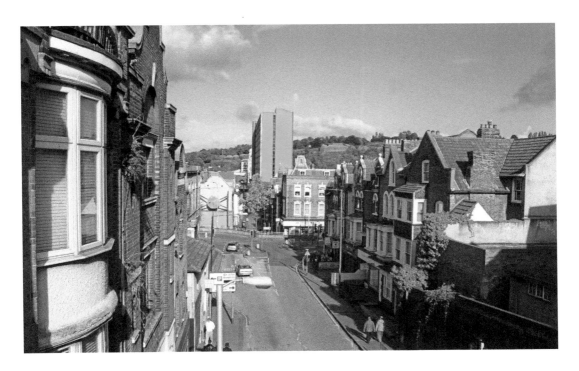

Railway Street

Mountbatten House now makes it virtually impossible to see the Town Hall while the raised road system saw the necessity to remove a few more Chatham buildings. The premises of W. E. R. Randall (23 Railway Street) is clearly visible in the early photograph, this is a long established company in the area and which merged with J. D. Walter & Sons in 1976, becoming Walter & Randall.

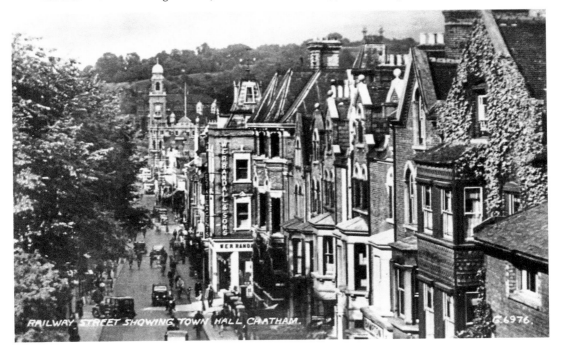

RAILWAY STREET SHOWING TOWN HALL, CHATHAM.

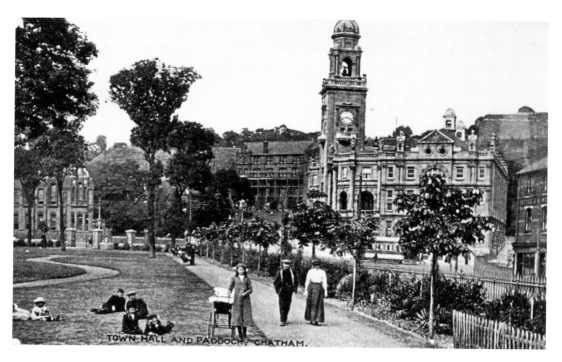

TOWN HALL AND PADDOCK, CHATHAM.

The Paddock

An area of grassland adjoining Military Road, the Paddock, is rarely given the priority it deserves. Whenever a new road building project is undertaken, the Paddock is either chopped about or re-shaped. This is also the situation with the current regeneration programme, with the Paddock having to be reduced for the new and highly controversial Waterside bus station.

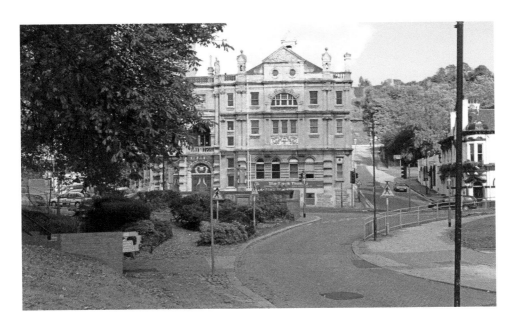

The Town Hall

Designed by George E. Best of Rochester, the Town Hall had its foundation stone laid in February 1898 and was completed some thirty-two months later. At that time the building was adequate for the administrative needs of the town while also offering space for dances and other ceremonial occasions. With the change of local government structure introduced in 1974, the Town Hall became less valued as a centre of administration and now has a much more significant community role. The date of the early photograph can be fairly precisely dated as having been taken in 1900. Supporting this conclusion is that of the building to the left, the Royal Sailors' Home, which is under construction (see page 69) and was not to be completed until February 1902.

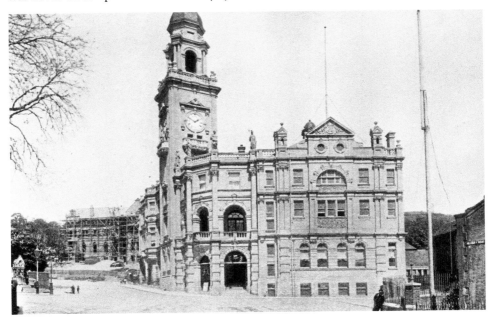

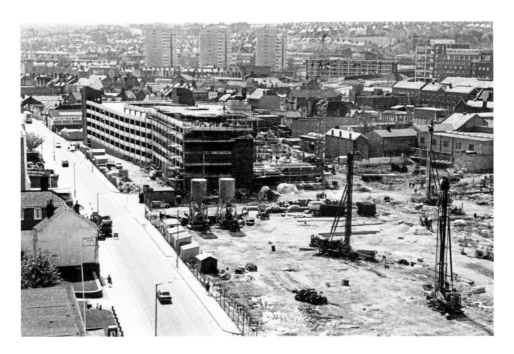

The Brook

Once the seediest and least pleasant of Chatham's residential districts, the Brook also housed the red light area. Much of this changed with construction of the Pentagon in the early 1970s, this large shopping complex also replacing an area of tightly-packed terraced housing. The modern day picture shows the interior of the Pentagon at a point approximately where George Street (which ran east from Military Road) intersected with Nelson Street (which ran south from the Brook) before running on to George Square and entering Fair Row.

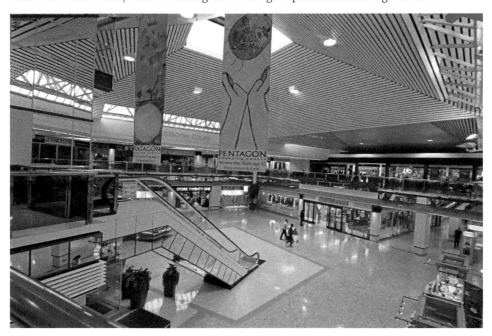

George Street

Although no longer in existence, George Street, which now lies buried under Mountbatten House and the Pentagon, is the road into which the small delivery van is turning. This entire swathe of buildings that once fronted Military Road were all removed in the early 1970s. Among shops and businesses that are shown in the photograph are those of Walter & Co. (surgical appliance makers), Williamson's (a greengrocer) and Tomlin's (a menswear shop). A further feature of Military Road at this point is that of most bus routes passing along the road, with a string of unenclosed bus stops. My own early memories of Chatham are those of queueing on cold winter evenings for buses that started their journeys from this point. At that time also, the skyline was overshadowed by a huge crane progressing on the then unfinished and unnamed Mountbatten House.

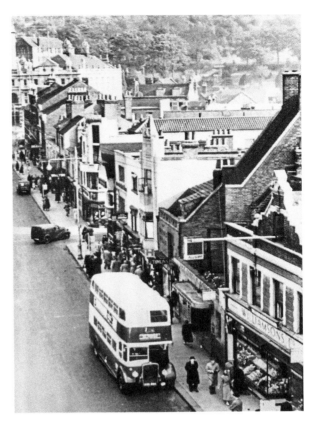

Sun Pier

In the summer of 1885 Chatham narrowly avoided a terrible tragedy when part of the publicly owned Sun Pier collapsed, throwing more than eighty people into the Medway. Dozens of people had to fight for their lives but no one was drowned or seriously injured. The cause was the collapse of a temporary walkway that stretched 80ft out to allow passengers to join pleasure steamers that traded between Southend, Upnor and Sheerness. This and a general history of the pier actually go unmarked on the structure. Some sort of orientation board would certainly add something to a fairly featureless structure that (as discovered by the cameras of BBC South) offer unrivalled views of Chatham and the river that has made the town what it has become.

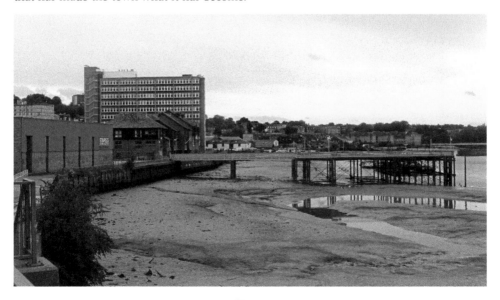

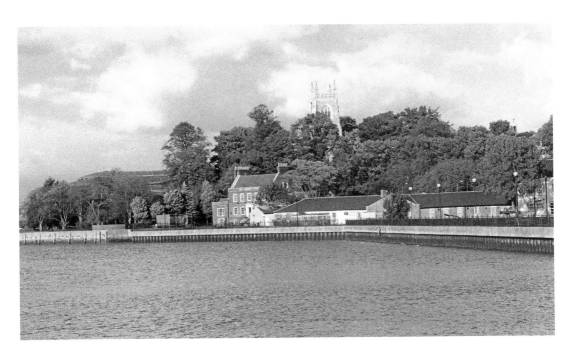

The River Medway

The centrepiece in both photographs, both old and new, is that of St Mary's, the former parish church. While no longer in service as a church, the building has changed little in the ninety or so years that separate these two pictures. Similarly, the Command House, which at the time of the earlier photograph was part of the Admiralty Ordnance Wharf, has also seen little outward alteration. Either side of these two buildings however, differences are quite considerable. In particular, a number of buildings that belonged either to the ordnance wharf or the adjoining Royal Marine Barracks have now been replaced.

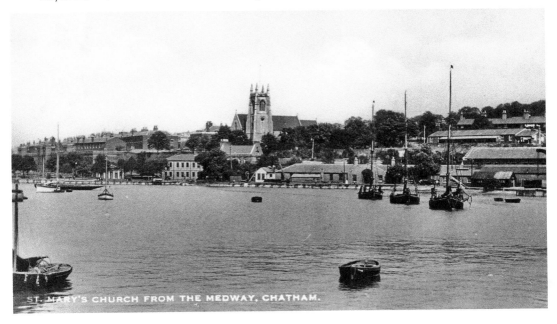

ST. MARY'S CHURCH FROM THE MEDWAY, CHATHAM.

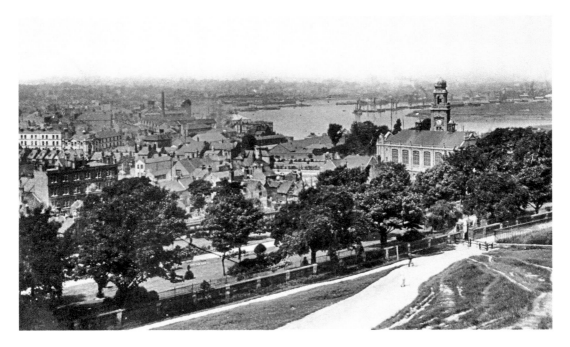

Chatham from the Great Lines

Although both photographs have been taken from the Great Lines, it is impossible to replicate the view of the early one because of the considerable growth of greenery. Of the numerous buildings to be seen in that photograph, the Town Hall is one of the few that remains unchanged with many of the buildings that lined the Medway having now been removed. Of the features in the modern day picture, most noticeable is St John's church in Railway Street.

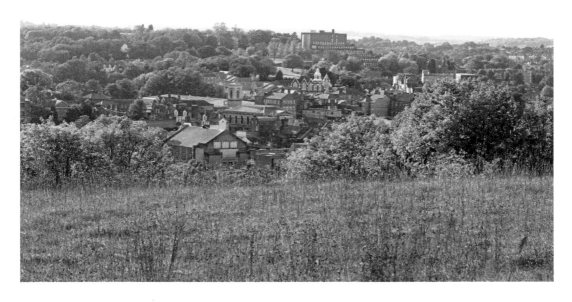

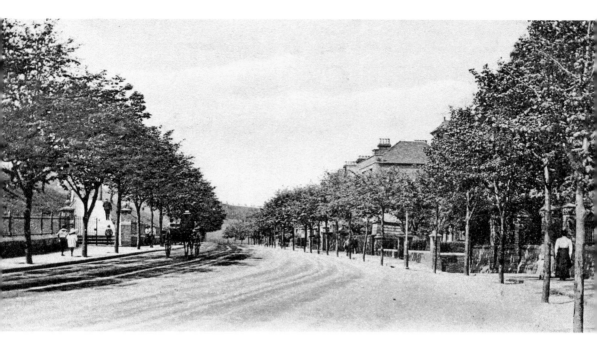

New Road

Constructed during the late eighteenth century, when it really was a 'new road', this particular thoroughfare was designed to speed traffic more quickly between Canterbury and London without becoming snarled up in the narrow roadway that ran through both Chatham and part of Rochester. As such, New Road, as a result of being built further back from the crowded inner town area, soon attracted the more affluent to build houses along much of its length. Still tree-lined, or at least this particular section, New Road is rarely as quiet as on that sunny day, during the reign of King Edward VII, when the earlier picture was taken.

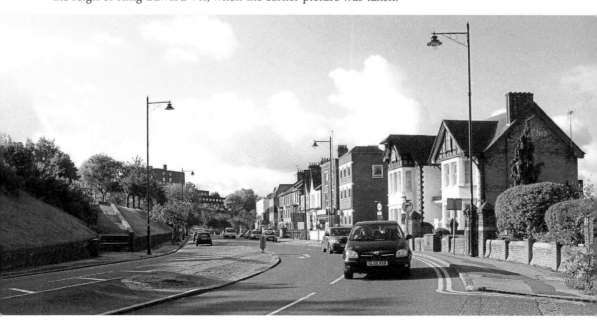

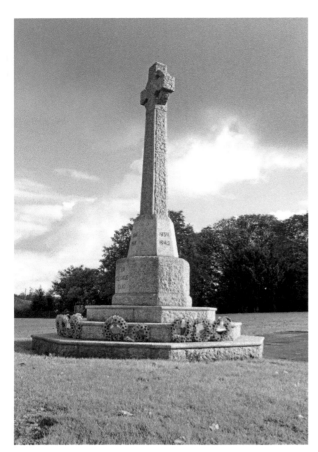

Chatham War Memorial

The original memorial was unveiled shortly after the First World War to mark the horrendous number of deaths that had been inflicted by this war. Among those with a Chatham connection who grieved was Charlotte Fullman who had lost all five of her sons. As well as losses on the various fighting fronts, Chatham suffered from aerial bombardment while food shortages had brought parts of the town to near-starvation. The further carnage of the Second World War led to additional inscriptions being added to the original memorial that still overlooks Chatham and is the centrepiece of a regular memorial service.

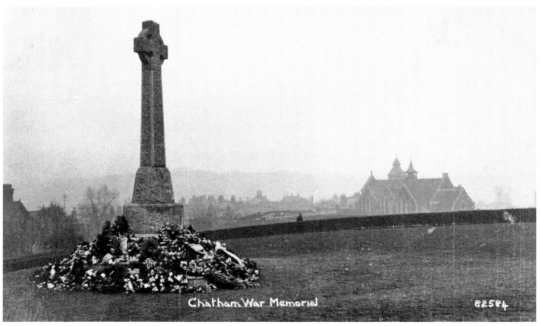

Chatham War Memorial 82584

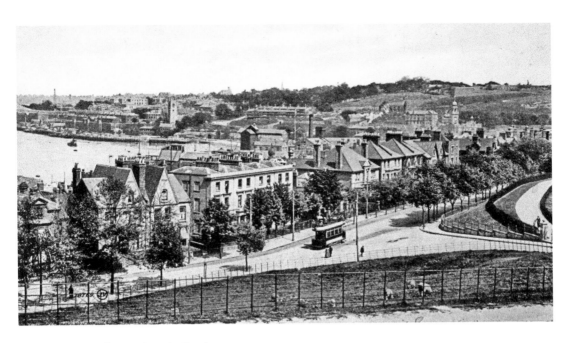

The View from Victoria Gardens

A further view that is difficult to replicate is a general view of the Medway as seen from Victoria Gardens. This time it results from extensive changes that have taken place within the area, mostly through the construction of a large number of much taller buildings on the higher slopes of the town.

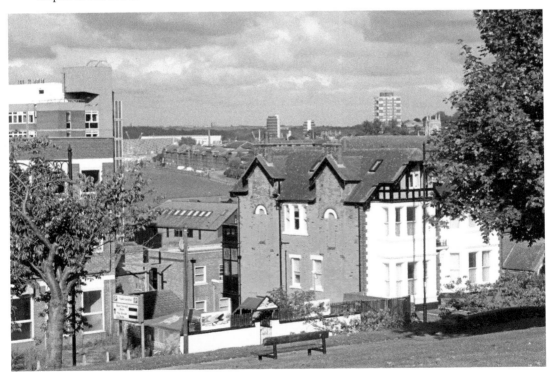

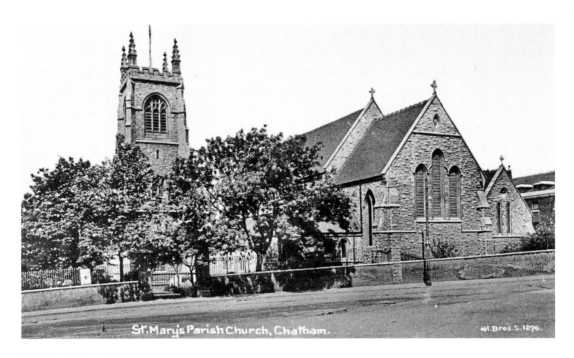

St Mary's Parish Church, Chatham.

St Mary's Church

The original parish church of the town, St Mary's, was declared redundant by the Church Commissioners in 1974 and shortly after became a Heritage Centre. Currently the church is awaiting a further determination on its future. As a building it has undergone numerous alterations that have taken it from a medieval Gothic-style building, through to a complete re-fashioning in the Classical-style followed by a return to its current mock Gothic exterior. Opposite the church building is an equestrian statue of Lord Kitchener in dress uniform (Grade II listed) which was placed here in 1959 following its removal from Khartoum.

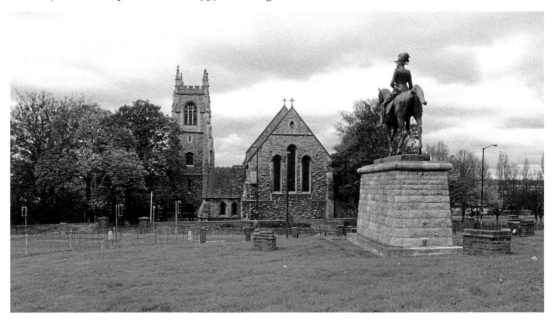

CHAPTER 2

The Outer Boundaries

Ordnance Place

One particular set of buildings that have escaped demolition are the Georgian buildings that make up Ordnance Place. Of particular significance is that one of the group (No. 11) was, between 1817-21, the home of Charles Dickens, then a young boy. While only a limited sojourn in the town for the future novelist, it nevertheless provided the future writer with a number of ideas he was later to use. He certainly remembered the dingy and overcrowded streets and various horrific tales that emanated from the workhouse (including the boy who asked for more). In 1821, however, the family was forced to move to the Brook – the least desirable area of Chatham – the family having fallen on hard times. Unfortunately, this particular house, 18 St Mary's Place, which might well have been worthy of preservation if given due care and attention, was demolished in 1943.

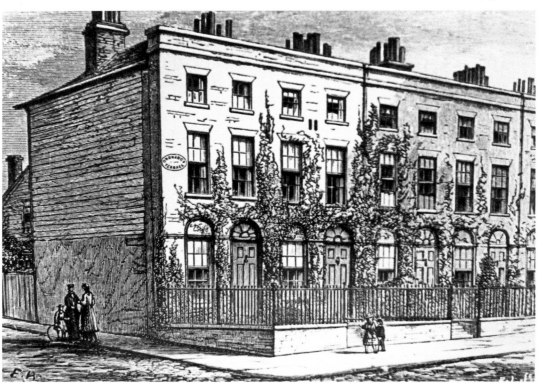

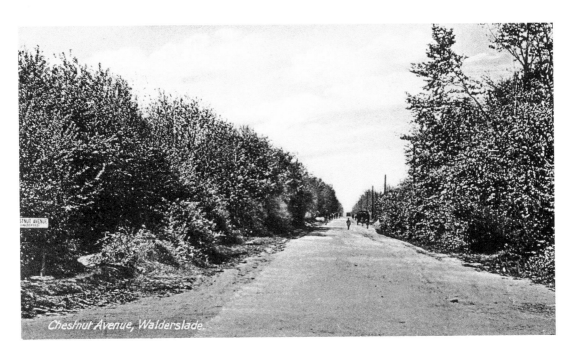

Chestnut Avenue, Walderslade.

Chestnut Avenue

During the 1920s Walderslade proved particularly attractive to those Londoners who were in search of a small piece of countryside. Chestnut Avenue itself can trace its origins to the decade or so immediately before the First World War when it was laid out in preparation for the sale of small parcels of land along its length. In the years that followed the First World War, many began purchasing these plots for the erection of small rural idylls.

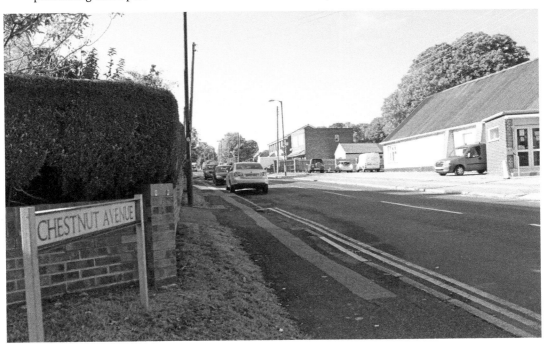

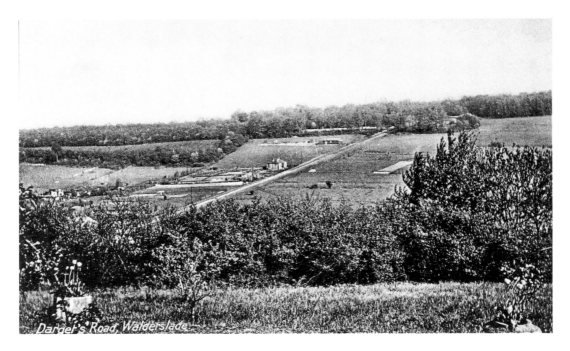

Darget's Road, Walderslade

Darget's Road

In common with Chestnut Avenue, Darget's Road was also first laid out in the years prior to the First World War, a result of an astute purchase by a land developer in 1902. It was in 1905 that Darget's Road School (now Walderslade Primary School) was first opened, the nearest school prior to that being Burham. Seen here in the 1920s, Chestnut Avenue was still in the early stages of development. Subsequent, and more determined development, has resulted in the road itself being now lined with housing but green fields are still in evidence to the south of the area.

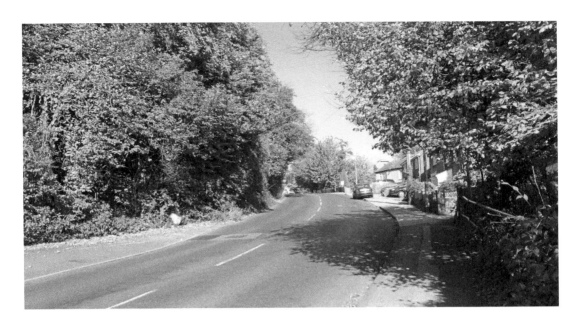

Walderslade Road

Walderslade Road pre-dates many of the smaller roads in Walderslade, being the original course of a much more ancient thoroughfare that ran directly past the original Manor of Walderslade (an area of land detached from the Manor of Chatham during the early middle ages). In 1836, the Manor was purchased by W. H. Brake, an auctioneer and estate valuer from Hampshire, who immediately began parcelling up the land he had purchased into small saleable plots that could be used for anything from the creation of a minor estate through to a smallholding for agricultural use. Areas of Walderslade Road that lie outside Brake's original (and subsequent) purchase, still remain free of housing but these are relatively few and far between when compared with the view of Walderslade Road taken in the 1920s.

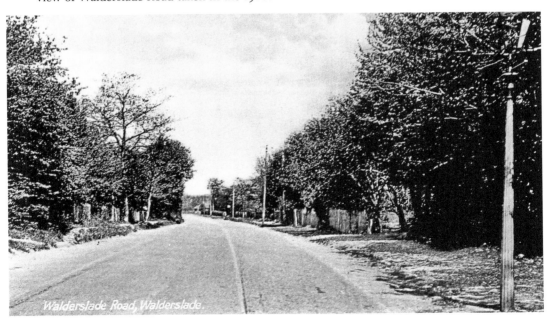

Walderslade Road, Walderslade.

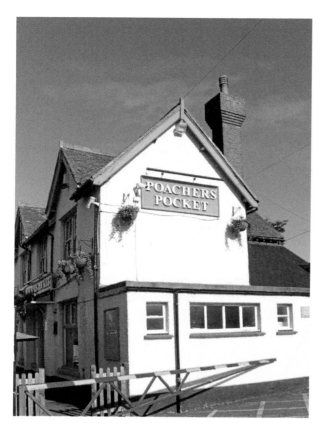

The Poacher's Pocket

Beginning life as the Hook and Hatchet, the Poacher's Pocket represented the extreme southerly part of the estate acquired by W. H. Brake in 1836. In the earlier photograph the then, Hook and Hatchet is viewed following a turn of the century heavy snowfall.

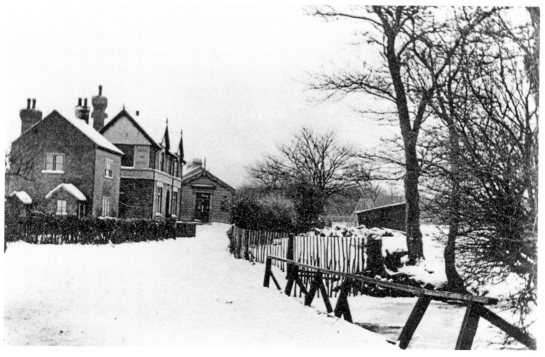

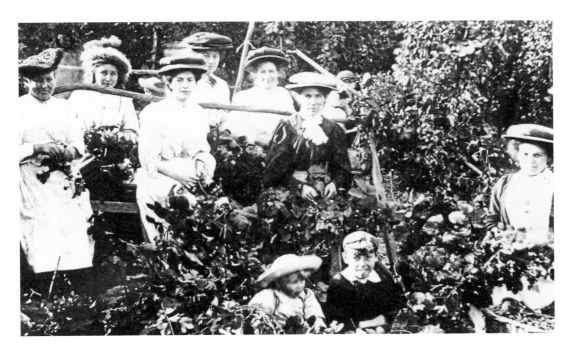

Hop Picking

Hop picking is a less familiar aspect of Chatham's history, but hop fields did once exist between Luton and Hale. This picture, probably taken in September 1906, shows a group of 'hoppies' gathered around a number of carefully filled baskets. The modern day picture looks out to Luton from Magpie Hall Road and provides evidence that much greenery still surrounds the crowded urban centre.

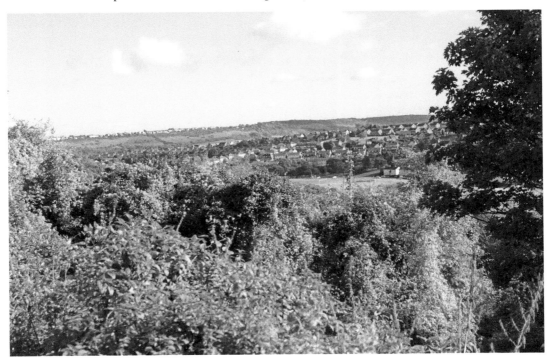

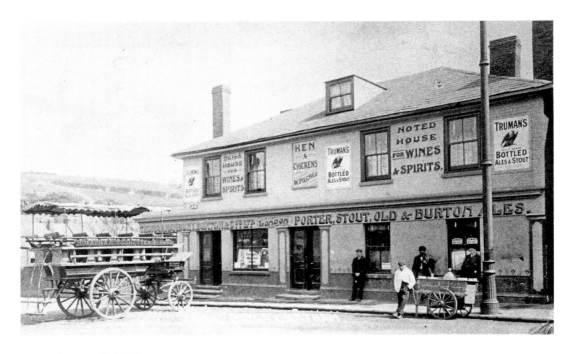

The Hen & Chickens

At one time the Hen & Chickens was the final stopping point on one strand of the Chatham tramway system. However, in the earlier of the two photographs, trams were but a distant dream. Instead, public conveyance, for those who could afford it, was by horse-drawn bus. Outside the Hen & Chickens, just such a vehicle is in view, its route sign displaying it as bound for Strood via both Chatham and Rochester. Leaning against his cart is an ice cream salesman, his cart proclaiming that only 'British ice cream' is sold. The landlord of the Hen & Chickens at this time was William Pilcher.

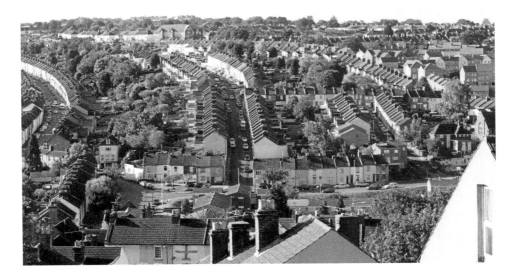

Luton

A feature of Luton that has remained unchanged since the early twentieth century is the tightly packed housing that came about both as a result of dockyard expansion and the introduction of trams. Those employed in the dockyard were no longer restricted by the distance they could walk each morning. They were now conveyed to the yard, quickly and cheaply, by the new trams. As a result, the more outlying areas of Chatham, especially Luton, became an attractive area for residence, leading to a sudden boom in housebuilding. The subsequent arrival of petrol-engined buses further boosted this trend, a point underlined by a series of destination boards that were originally carved into the lengthy brick wall of the naval barracks and which stands immediately adjacent to the dockyard's original Pembroke Gate.

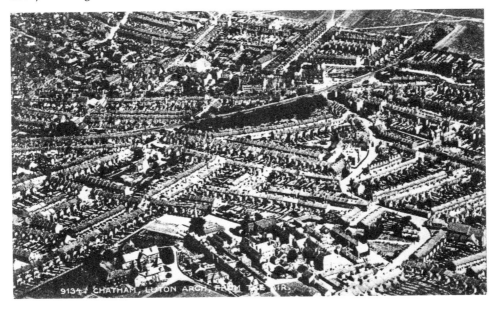

All Saints Hospital

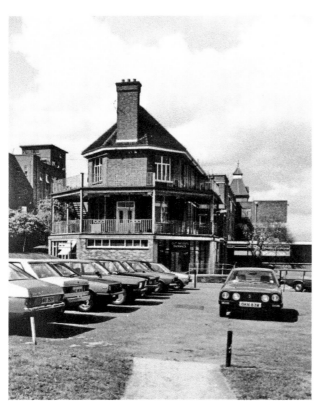

The hospital, which was closed in 1999, began life as a workhouse. The earlier picture, which dates to the mid 1980s, shows the Phillippa and Ruth wards. However, the All Saints complex was not the workhouse that would have been known to Charles Dickens when he lived in Chatham at the beginning of the nineteenth century. Instead, the workhouse that supposedly influenced Dickens in the writing of *Oliver Twist* was situated on the Brook and on the site of the current Ritz Bingo Hall. It was on 23 November 1859 that the residents of this earlier Chatham workhouse were transferred to the new building on Magpie Hall Road. Following the closure of the hospital, modern housing covers some of the site, with some original buildings retained and integrated into a newly created community facility.

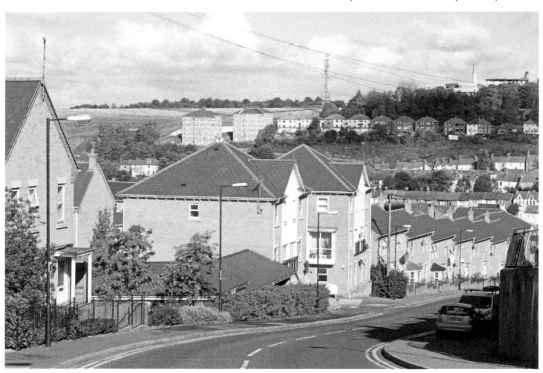

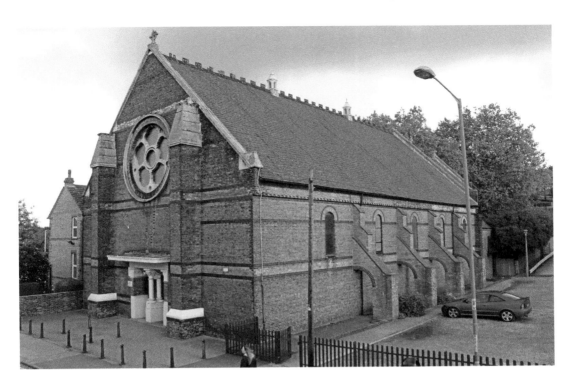

St Michael's Church

St Michael the Archangel is a Roman Catholic Church that was built 1862/3 and is situated in Hills Terrace. In the highly respected 'Buildings of England' series, published by Penguin, the church receives a somewhat mixed write up, described as having a 'cheap but very powerful nave' and a 'weak chancel'. The earlier picture, which dates to the 1930s, shows the 'powerful' nave of the church, which was constructed at a cost of £1,695.

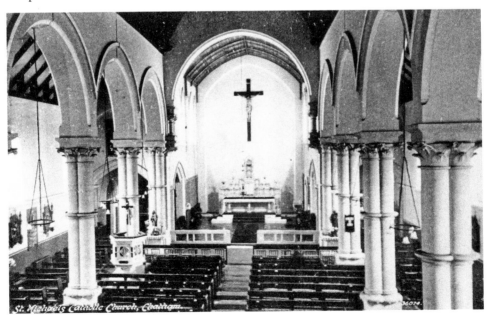

St. Michael's Catholic Church, Chatham.

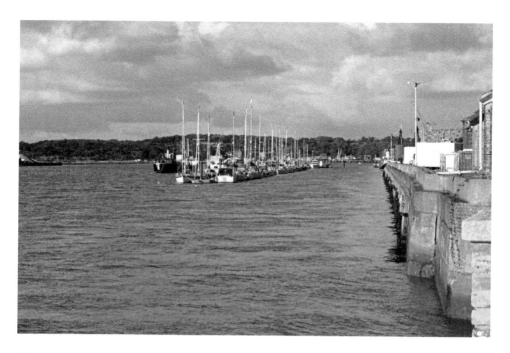

River Medway

At one time the River Medway, where it passes through Chatham, was one of the busiest waterways in the country. While part of this was a result of the dockyard, the town frontage itself also possessed a number of wharves and warehouses. Here, in this late-Victorian scene, a view is taken that looks from Chatham across the river (known at this point as Chatham Ness) towards the Frindsbury Peninsula. A number of barges are moored on the Chatham side while a number of other vessels are progressing up and down the river. Nowadays there is very limited industrial movement on the river and virtually none generated from Chatham. Instead, as represented by this line of pleasure craft moored off the dockyard, pleasure boating now dominates the Chatham reaches of the river.

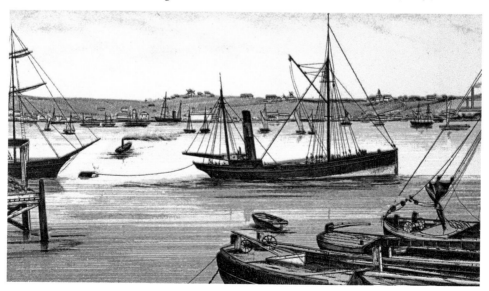

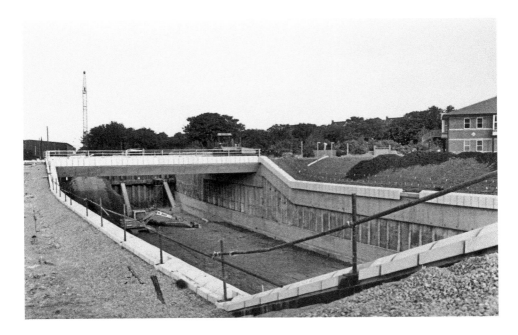

Medway Tunnel

Forming part of the Medway Towns Northern Relief Road, the tunnel is important to Chatham as it allows traffic that might otherwise pass through the town now being taken on a more northerly route. Its construction came as a direct result of the closure of the dockyard and the releasing of St Mary's Island into the public sector. In these two contrasting photographs, both taken at the point where the tunnel opens out onto St Mary's Island, work on its construction (1995) can be compared with its later completion and current use (2010). Ownership of the tunnel's freehold is in the hands of the Rochester Bridge Trust but leased for 999 years to Medway Council with the tunnel opened by the Princess Royal on 12 June 1996.

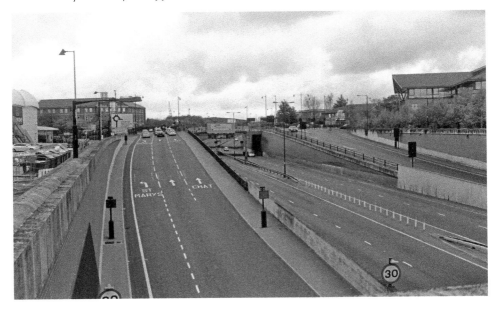

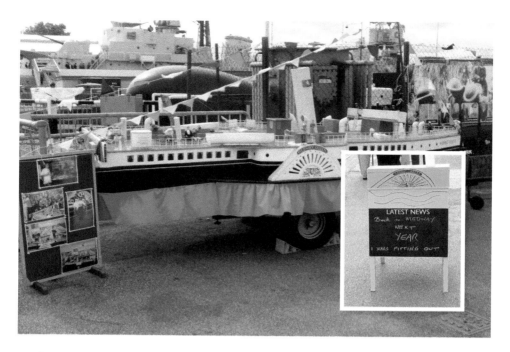

Medway Queen

It is planned that the *Medway Queen* will be returned to Chatham in 2011 following a rebuild at Bristol. A paddle steamer with a strong local connection, she is the last estuary pleasure steamer surviving in the UK. That the *Medway Queen* has been saved from the scrapyard, once a very real possibility, is due entirely to the work of the *Medway Queen* Preservation Society. Members of the Society have worked tirelessly since 1984 to save the vessel and raise sufficient funds to allow her to be brought back into steam. The model of the paddle steamer, seen here at Chatham dockyard in September 2010, has proved an important asset in publicising the work of the Preservation Society.

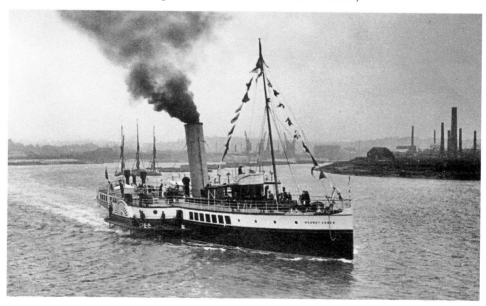

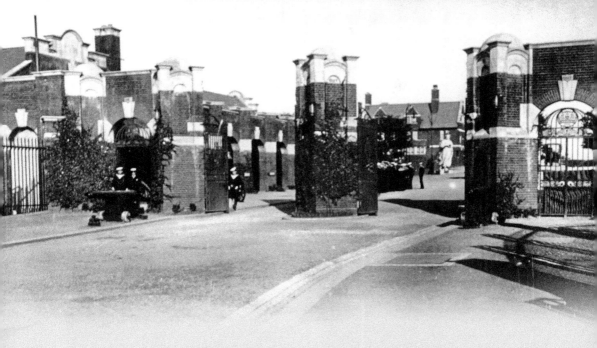

The Naval and Military Connections

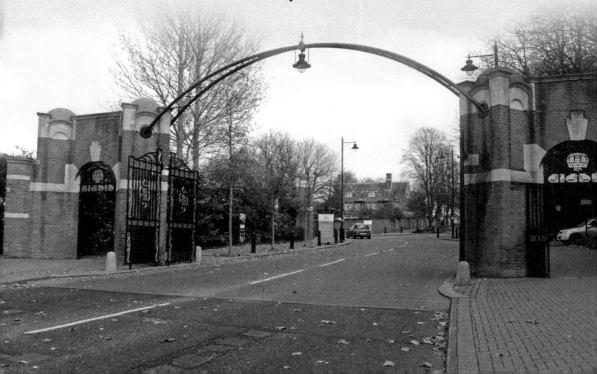

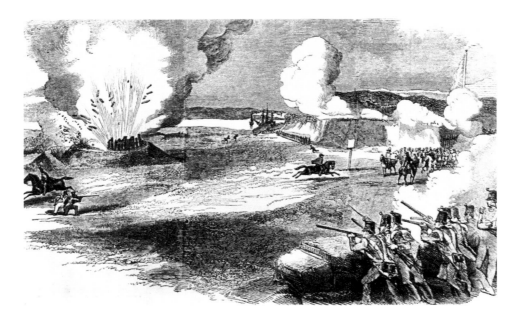

Fort Amherst

Fort Amherst, which was built towards the end of the eighteenth century, was part of a massive line of defences built to protect the landward side of the dockyard. The fear, particularly in the period of constant war with France, was that an army landing in either east or south Kent, and marching across country, might capture the dockyard. In later years Fort Amherst, together with the entire length of the landward fortifications, by then known as the Chatham Lines, was frequently used for practice manoeuvres as depicted in this nineteenth-century print. In later years, and serving as a useful visitor attraction, the same manoeuvres, now carried out in period costume, still continue.

Previous page: Main gate, HMS *Pembroke*. Formerly the entrance to the naval barracks, passing through this same gateway will now bring the visitor to a mixture of Higher Education institutions.

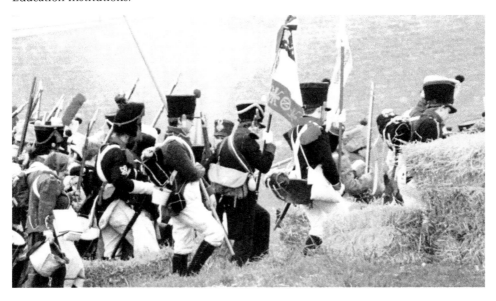

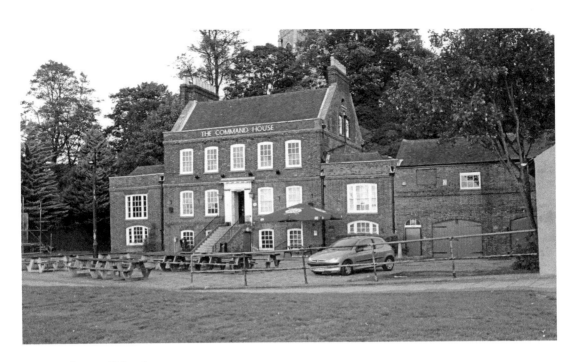

Ordnance Wharf

The Ordnance, or Gun Wharf, stood alongside the River Medway and had, at its most southerly point the area now known as Riverside Gardens. It was here that naval guns were stored and maintained. Originally it was not a naval establishment, being administered by the War Office through the Ordnance Board. Established during the early part of the sixteenth century, the Chatham Ordnance Wharf first occupied the site of the original Tudor dockyard. The earlier picture shows the Ordnance Wharf as it appeared in the mid to late nineteenth century. The modern day photograph is of the Command House, a building that once formed part of the Wharf when it served as the house of the Deputy Armament Supply Officer. It is also visible in the earlier picture.

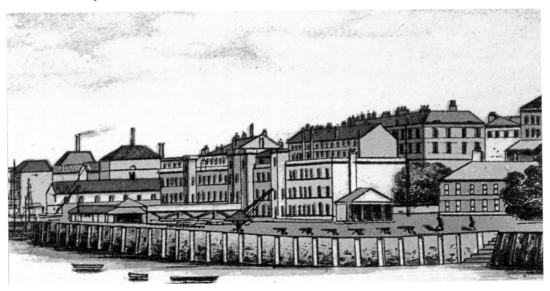

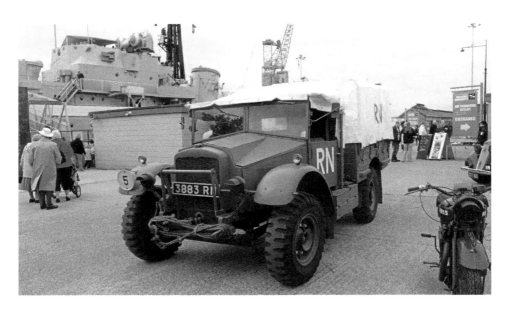

The Old Salts

At one time a most common sight around Chatham and its dockyard were the serving seamen of the Royal Navy. In the evenings the naval blue jacket would either be crowding the railway station awaiting the next train to London or descending on the pubs and music halls that lined the High Street. In daytime however, they would be engaged in tasks that ranged from keeping the barrack parade ground swept and clean through to the assisting in the fitting out and storing of ships. Here, a group of blue jackets, *c.* 1901, sit astride ropes and other tackle outside the No.12 Storehouse in the dockyard. *Khartoum* was one of several small industrial locomotives that eased the problem of constantly moving heavy materials around the yard. In fact, there were few buildings in the yard that were not directly connected to the rail system. The modern day picture is of a naval vehicle much more common to the dockyard in the Second World War, but here seen as part of a heritage event held at the dockyard in September 2010.

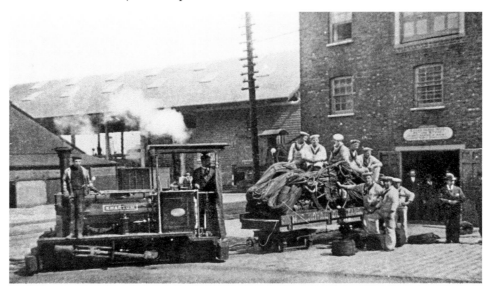

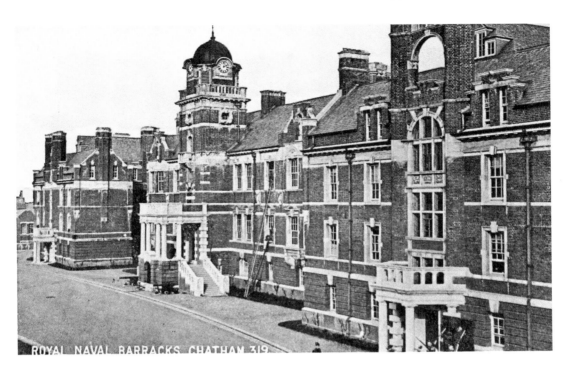

The Royal Naval Barracks

The naval barracks at Chatham, named HMS *Pembroke* were completed in 1903. For those in training or awaiting a transfer to a new ship, the barracks were a marked improvement upon the old hulked warships of the Medway that had previously served this purpose. The earlier photograph shows part of the barracks shortly after completion while the old parade ground is to be seen in the modern day photograph.

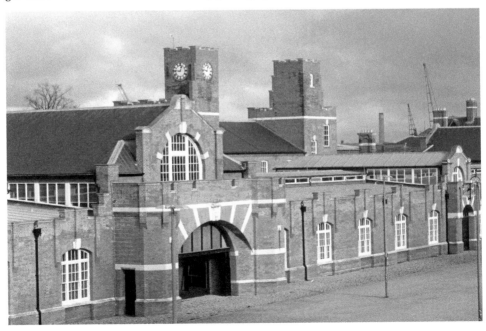

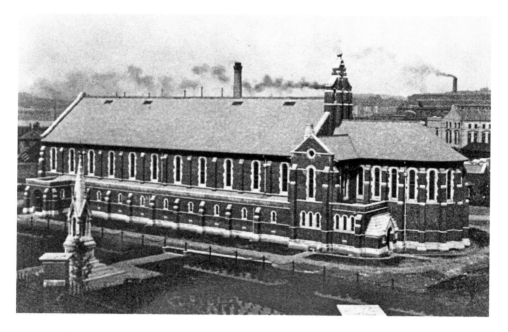

St George's Chapel

Built in 1905 to serve the needs of the Royal Naval Barracks, St George's remains little changed. Now it is a conference venue but continues to proclaim its connections with the Royal Navy through a number of memorials contained within the building. Outside, and to be seen in the earlier photograph, is a further memorial (removed from St Mary's Island in 1906) and marking the graves of French prisoners who had died in captivity during the French Revolutionary and Napoleonic wars. These prisoners had originally been buried on St Mary's Island, but with a subsequent need to develop the area in which they had been buried, both the skeletal remains and the memorial were moved to this new site that adjoins the chapel.

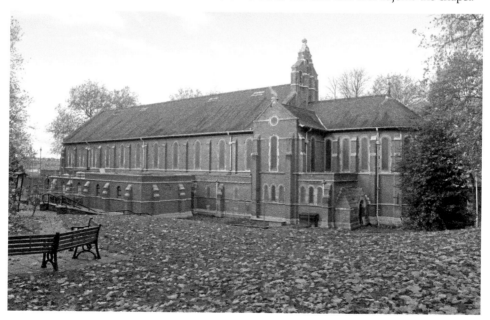

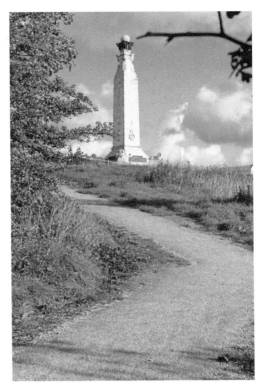

Royal Naval War Memorial

Overlooking the town of Chatham and approached from a pathway leading out of the Town Hall gardens, the Royal Naval war memorial was originally constructed after the end of the First World War to commemorate those who had died while serving in the Royal Navy and had no known graves. It had been further decided that each of the three naval manning ports – Chatham, Plymouth and Portsmouth – should have such a memorial, the design in each case being identical.
Sir Robert Lorimer was the designer and Henry Poole the sculptor. The modern day photograph shows the subsequent additions to the memorial that were made after the Second World War, so allowing commemoration of those who died without graves in this war. In all, the Chatham memorial commemorates more than 8,500 sailors from the First World War and 10,000 from the Second World War.

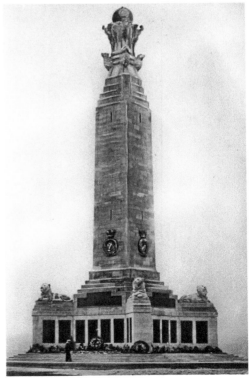

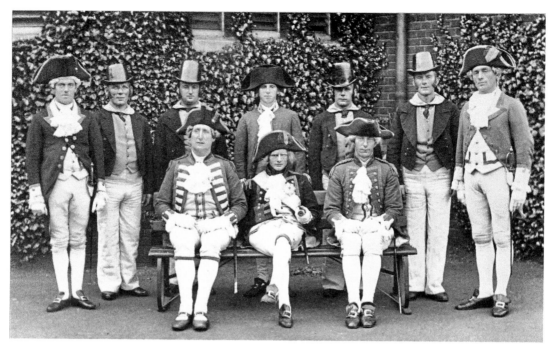

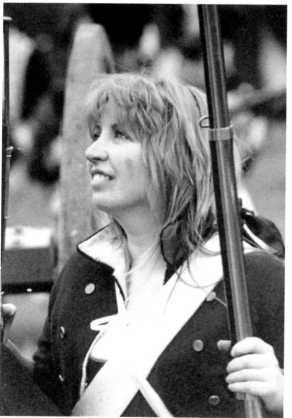

Military Re-enactments

Military re-enactments have long been popular in Chatham. Often used by the Royal Navy and Royal Marines to encourage recruitment, they would centre on past battles and past successes. In the earlier picture a group of seamen from the naval barracks have been conscripted in a pageant held in August 1912 that depicted various scenes in British history. Here, of course, they are dressed as the men and officers of HMS *Victory* on the eve of Trafalgar (21 October 1805), with a realistic depiction of Admiral Nelson (seated centre) also included. Moving to modern day Fort Amherst, a female participant takes charge of a few spare muskets. She is possibly a member of a Fort Amherst re-enactment group that models itself on the Royal Foot Artillery of the early nineteenth century.

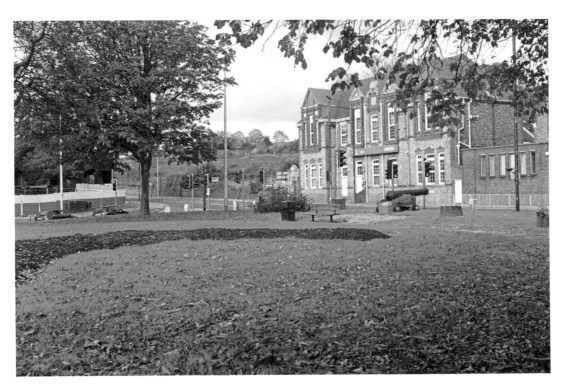

Royal Marine School
Situated near the Paddock, the Royal Marine School building constructed during the late nineteenth century now serves as an Army and Navy recruiting office.

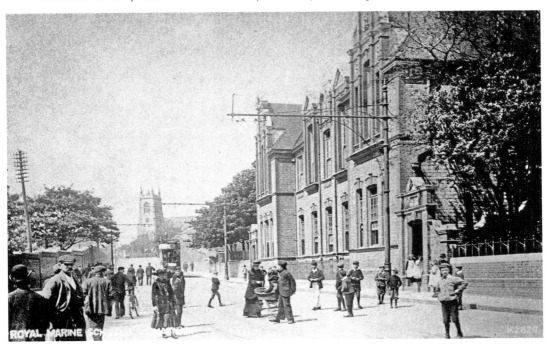

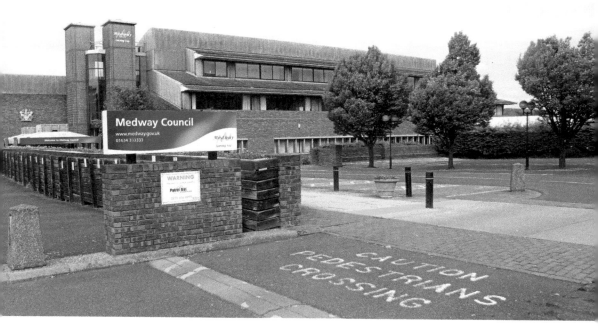

Main Gate, Royal Marine Barracks
The Royal Marine Barracks, built sometime around 1779, was closed in 1950 and demolished a few years later. Located midway along Dock Road, it is now the site of the Medway Council administrative buildings.

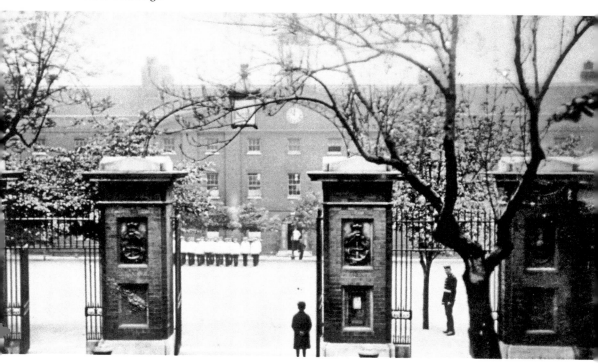

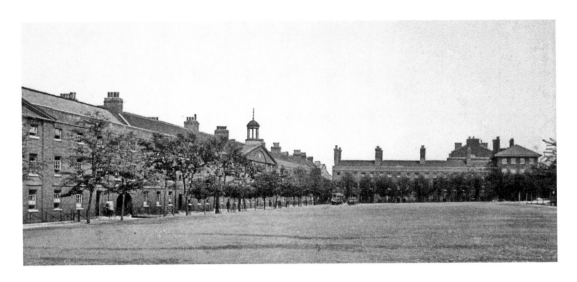

Medway Council Gunwharf

To those using the new riverside footpath or cruising the river, the Medway council offices are proclaimed as the Gunwharf. Clearly confusion exists, as the sign adjoining the same building declares this same site as to have been part of 'the barracks of the Royal Marines Chatham Division'. Perhaps a degree of explanation is required. The Gunwharf building, sited slightly back from the river, does actually stand on the grounds of the former barracks and should be more correctly named Medway Council Marine. Similarly, the commemorative stone, being slightly nearer the river, is on the site of the former Gunwharf that stood alongside the river frontage with the barracks immediately behind it. The earlier photgraph is a view of the parade ground, an area now occupied by the Medway Council Gunwharf building.

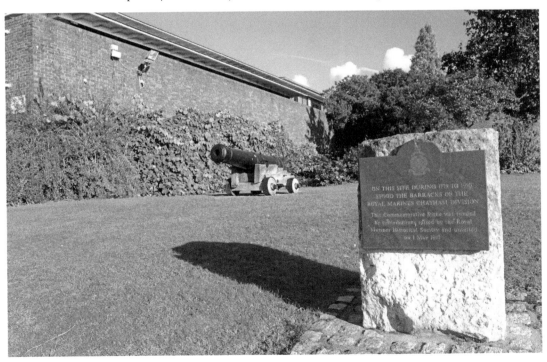

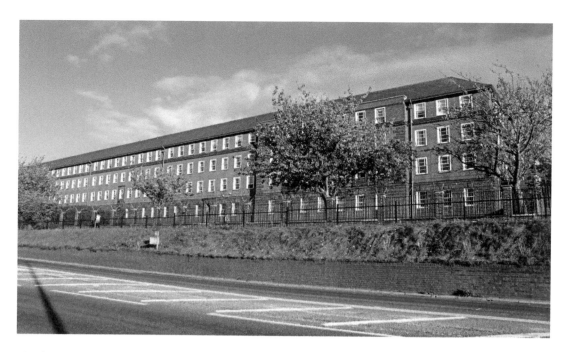

Chatham Barracks

Originally constructed as an infantry barracks that accommodated soldiers manning the Chatham Lines, Chatham Barracks (later re-named Kitchener Barracks) was originally constructed in 1757. Many of the current buildings on the site, including those in the modern view date from the 1930s, with only a very few of the earlier buildings remain. In the earlier view, which dates to the end of the reign of Queen Victoria, it is possible to appreciate how some of the earlier barrack blocks appeared at the time of original construction.

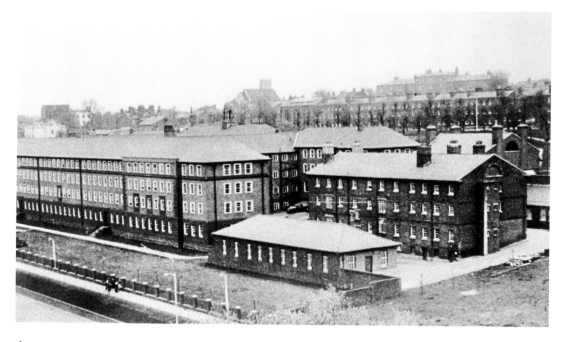

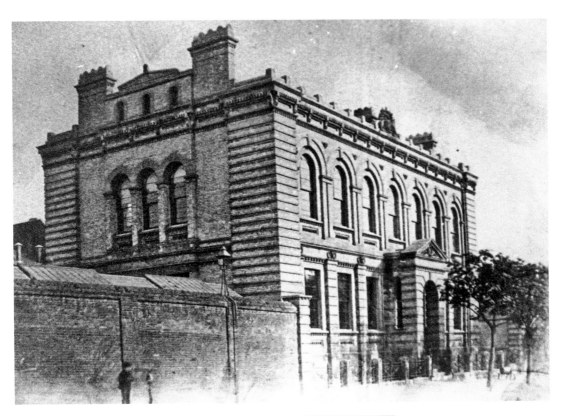

Soldiers' Institute and Garrison Club

Forming part of the boundary to Chatham Barracks, but not constructed until 1861, was the Soldiers' Institute and Garrison Club. Designed to meet the off-duty needs of those serving in the barracks, it was the forerunner of a number of military social clubs that were built in Chatham towards the ends of the century (see pages 68-9). Among facilities available were smoking and coffee rooms, a bar, library and bowling club while a lecture theatre was added in 1872. The building itself no longer exists but its location, alongside Dock Road is easily found, the original entrance portico lies embedded into the wall that encircles the barracks. It seems likely that Chatham Barracks will soon be disposed of and plans exist to more fully incorporate the site into the Brompton Lines Conservation area. At such time, it seems likely that remaining eighteenth-century buildings will be preserved and an archaeological exploration undertaken.

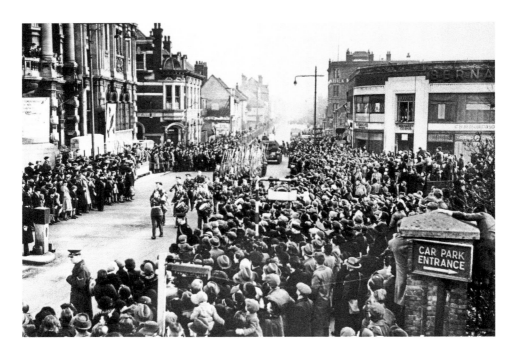

Wartime Conflict

Chatham during the Second World War was a major target. Although subject to a number of air raids, it received nothing like the damage inflicted upon the other two southern England dockyard towns, those of Portsmouth and Plymouth. Support within the town for the British war effort was immense, with donations for various wartime causes frequently exceeding the set target. One such event was War Weapons Week, with the parade to mark that occasion being held on 11 February 1941. The Town Hall, to the left, has an anti-blast wall built in front of it. In the dockyard, the evacuation of Dunkirk, which involved many ships and crews based in Chatham, is re-enacted at the dockyard.

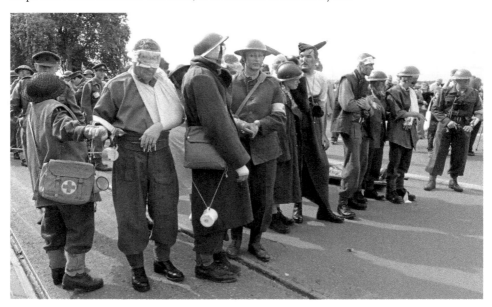

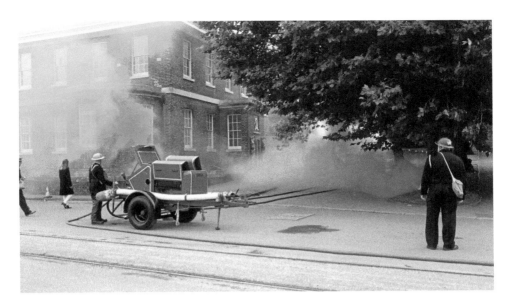

The Auxiliary Fire Service

The possibility of Chatham suffering damage from a series of intensive air raids was recognised long before the outbreak of the Second World War. To meet such a threat, a recruitment campaign was undertaken in the borough to encourage both men and women to enlist into the Auxiliary Fire Service (AFS), a voluntary body that trained and worked alongside the fulltime fire fighters of the borough. Once war broke out, those who had joined the AFS would, themselves, become full time paid firemen for the duration of hostilities. On 3 September 1939, therefore, a number of buildings throughout Chatham were placed at the disposal of the AFS, so ensuring that they were spread right across the borough. In these two photographs, the men of the AFS (women were employed on administrative duties only) are seen demonstrating their prowess in the months leading up to the war while, in contrast, a modern re-enactment is undertaken within the confines of the historic dockyard.

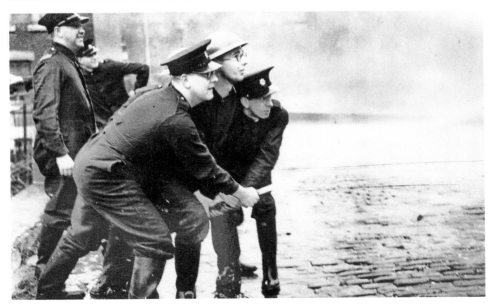

Welcome Soldiers and Sailors Home

To provide an opportunity for both soldiers and sailors to have somewhere to relax outside of the potentially oppressive barrack regime, a number of charitable organisations were responsible for establishing social clubs within the town for military personnel to visit. Not to put too fine a point on it, many of these were deliberately established in or close to 'the red light area' for the purpose of offering in those areas something that might attract both Tommy Atkins and Jack Tar away from the ladies of the night. One of the most important of these was the Welcome Soldiers and Sailors Home in Military Road. First established in 1877, it originally consisted of the square four-storey structure that stood beyond the later and more ornate building that formed a frontage on the corner of Military Road and Medway Street. Nowadays, locally based fashion retailer, Red Menswear, occupies this later addition to the home.

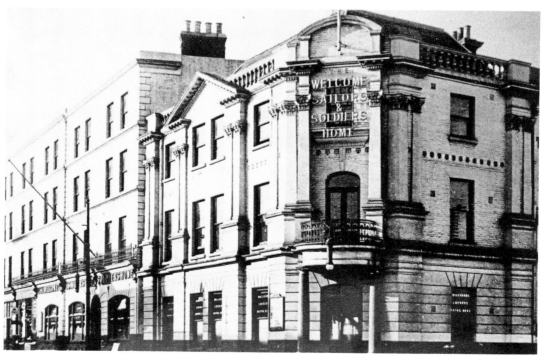

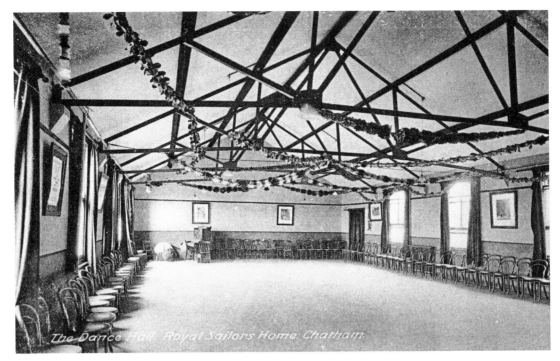

The Dance Hall, Royal Sailors Home, Chatham.

Royal Sailors' Home

A further institution, but this time more exclusively for those in the Navy, was that of the Royal Sailors' Home which stood just behind the Town Hall in Upper Barrier Road. Recently demolished, the Royal Sailors' Home has been replaced by a more modern residential block. The original building, of which the early photograph shows the dance hall, was a rather austere brick building that had been financed by the Admiralty. Progress on its construction can be seen on page 29. Designed by George E. Bond, a noted architect of Rochester, it was to have stretched the entire length of Upper Barrier Road, but a planned west wing was never constructed. It was opened in February 1902 and provided both overnight accommodation and club facilities.

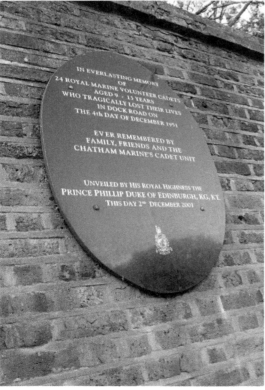

The plaque reads:

IN EVERLASTING MEMORY
OF
24 ROYAL MARINE VOLUNTEER CADETS
AGED 9 — 15 YEARS
WHO TRAGICALLY LOST THEIR LIVES
IN DOCK ROAD ON
THE 4th DAY OF DECEMBER 1951

EVER REMEMBERED BY
FAMILY, FRIENDS AND THE
CHATHAM MARINE'S CADET UNIT

UNVEILED BY HIS ROYAL HIGHNESS THE
PRINCE PHILLIP DUKE OF EDINBURGH, KG, KT.
THIS DAY 2nd DECEMBER 2001

The Dock Road Tragedy

The marked off area following the terrible tragedy in Dock Road that cost the lives of twenty-four members of the Royal Marine Cadet Corps. During the evening of Tuesday 4 December 1951, members of the Cadet Corp, all aged between nine and fifteen, were marching in the road, heading to the dockyard where they were to watch a boxing tournament. Darkness had already fallen on a foggy evening and yet members of the marching column carried no form of lighting. Added to all this, was that Dock Road was poorly lit and the bus that drove into them was not using its headlights. At the time it was the worst road accident ever to occur in the United Kingdom and continues to serve as a reminder of how continuing efforts are always needed to bring ever-greater safety to roads and how they are used. The plaque, which remembers the event, is located close to the scene of the tragedy.

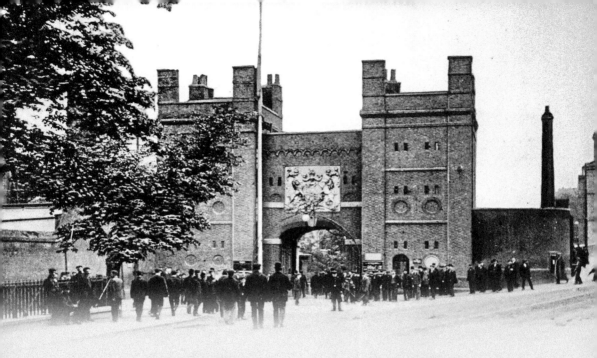

CHAPTER 4

The Dockyard

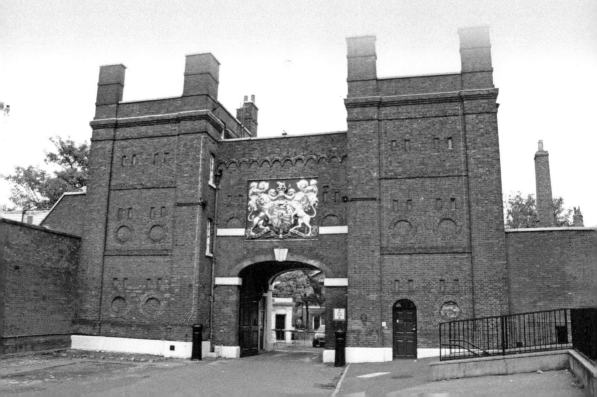

Pembroke Gate

At the end of the dockyard working day, and always signalled by the tolling of the dockyard bells, the work force makes a rapid egress. In the early twentieth century, most would be reliant on a line of trams that would have been drawn up ready to meet them. From September 1930 onwards, when trams were replaced, this was a task given over to buses. Of course, by that time, many of those employed were also using bikes to make their way home, with Dock Road quite impossible to cross when this stream of traffic was on the move. To bring some sense to this scene of potential chaos, the wall at the lower end of Dock Road, on the northeast side, was provided with the addition of white stone markers that indicated the destination of the bus parked nearby. Recently these have been restored but it is accepted that the destinations now displayed may not, necessarily, be in the original correct order.

Previous Page: The main gate to the dockyard seen at the beginning of the twentieth century. On this occasion the workers are entering rather than leaving the yard.

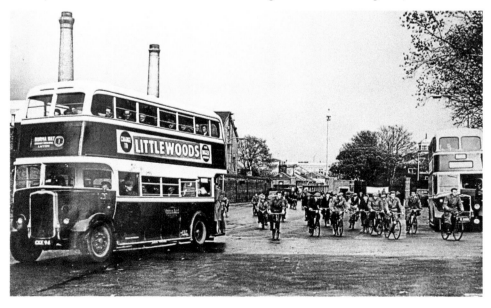

Cooper's Row

These buildings are partially covered with asbestos. This was left over from the 1930s when there was a great fear of aerial bombardment and a need to protect the aged wooden buildings of the dockyard from a potential high risk of fire. The three buildings to be seen in the earlier photograph were, throughout much of the twentieth century, simply used as stores, having originally been constructed as a wheelwright's shop (for the repair of carriage wheels) and as a mast store. The modern day picture not only shows how the Chatham Historic Dockyard Trust is using the buildings of the earlier photograph but also permits a glimpse of a further range of mast houses that are part of the Wooden Walls exhibition and for which the present writer contributed much of the historical background.

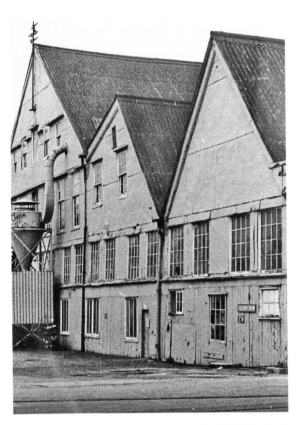

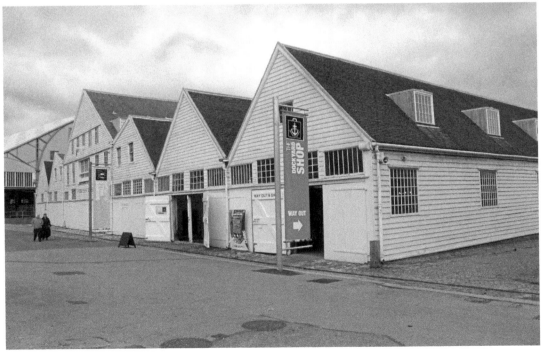

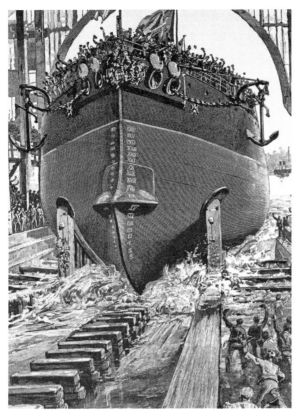

The Launch of HMS *Rodney*

The 'Admiral' class battleship HMS *Rodney* was launched at Chatham dockyard on 8 October 1884 and was commissioned in the Medway nearly four years later. Built beneath the coverings that were placed over a number of the building slips of the yard, these roof structures had to have sufficient height as to provide sufficient space for the building of the massive hulls of these warships. Nowadays the building slips remain, although their use has altered quite significantly.

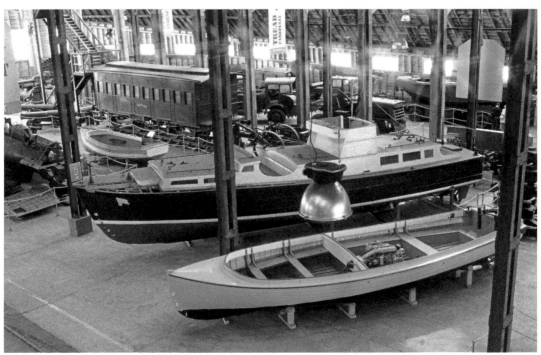

Docks and Slips

In the modern view, one of the dockyard's most impressive features, that of its collection of covered slips, can be clearly seen. In the earlier photograph, which also includes the destroyer *Greyhound* held within Dock No.4, only a partial glimpse of No.3 slip is to be noted. Of the various slip covers, that of No.3 (nearest to the camera in the top photograph) is the earliest, having been roofed over in 1838. As for the next three slips (moving away from the camera) these were all given cast iron covers in 1847-8 while the final slip (furthest from the camera) was covered in 1855.

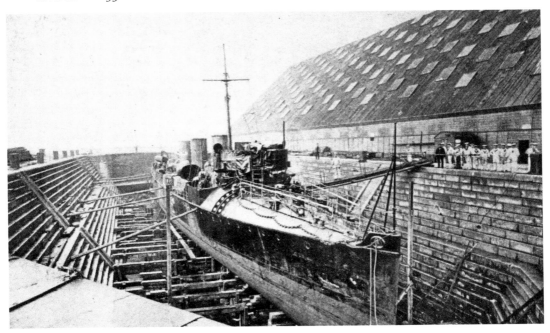

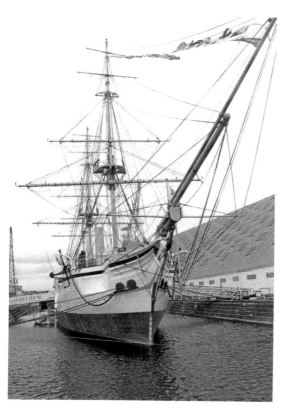

Gannet

The 'Dotterel' class sloop HMS *Gannet* was originally launched at Sheerness dockyard in August 1878 and went on to serve in the Pacific, Mediterranean and Red Sea. Briefly, also, she served at Chatham as a harbour service vessel before (and under the new name of *President*) eventually being sold out of service and becoming a training ship. In 1987 she eventually returned to the Medway and began a lengthy period of restoration at the dockyard. In these two pictures, a comparison can be made between how she appeared on her first arrival and how she now appears with her restoration complete.

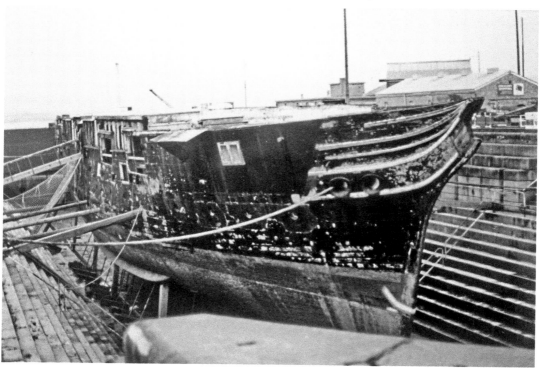

Cavalier

Built by J. Samuel White of Cowes on the Isle of Wight, *Cavalier* was launched in April 1944. Undertaking a limited amount of wartime service, she was retained in the post-war navy with her active career extended by a period of modernisation in 1957. Following decommissioning at Chatham she was acquired for purposes of restoration and transferred to the Historic dockyard in 1998. Since that time she has become an important visitor attraction. In the earlier picture of *Cavalier*, she is present at the dockyard in 1979 for that year's Navy Days.

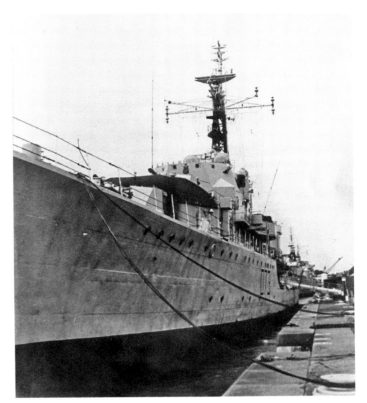

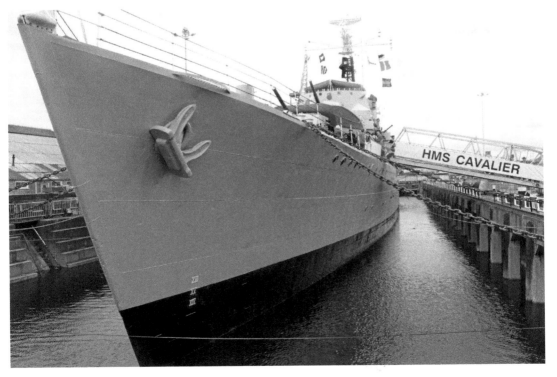

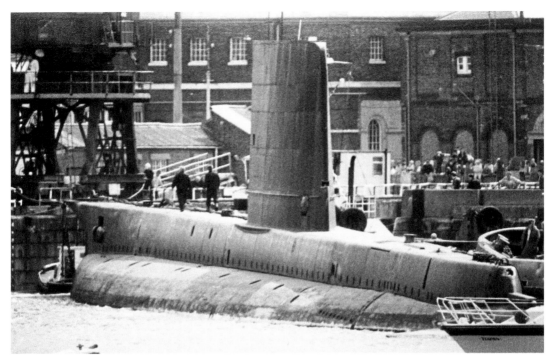

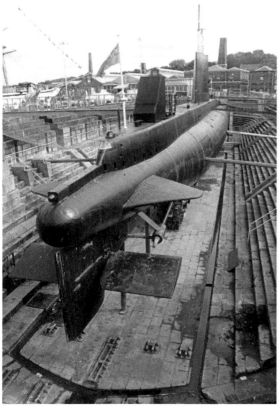

Ocelot

Ocelot was the last submarine built at
Chatham for the Royal Navy, although
three other similar submarines were
built in the dockyard for the Royal
Canadian Navy. Launched in 1963, she
was returned to Chatham in 1991 (seen
in the earlier photograph on her arrival
on that occasion) when she was paid off
prior to her being prepared as a visitor
attraction.

Anchor Wharf

The date of the early photograph can be precisely dated to 11 November 1918. Workers employed in this area of the yard, which lies at the south end of the dockyard, are posed under flags that have been thrust out of windows to celebrate the armistice that brought the First World War to a close. The Anchor Wharf was once used to store anchors manufactured in the dockyard prior to their removal to seagoing warships. The building in the immediate foreground, the No. 1 Rigging House, now houses (in Block B) the dockyard museum that is jointly run by the Historic Trust and the Dockyard Historical Society.

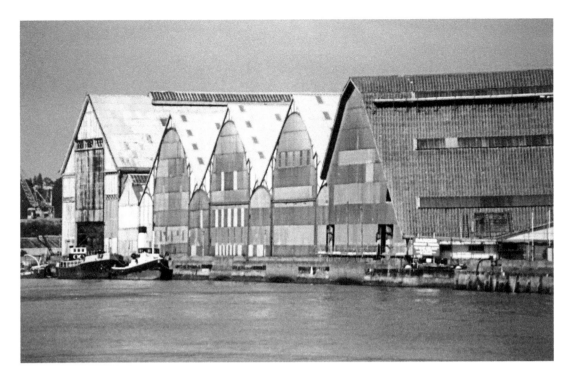

Launch of Goliath and Virago

Although it was rare to launch two ships on the same day, this otherwise typical launch scene from 1857 provides an excellent view of the covered docks and slips that formed the dockyard river frontage at that time. Over 150 years later, the scene has a certain similarity, although only the two slips nearest the camera (Nos. 3 and 4) are to be seen in the engraving.

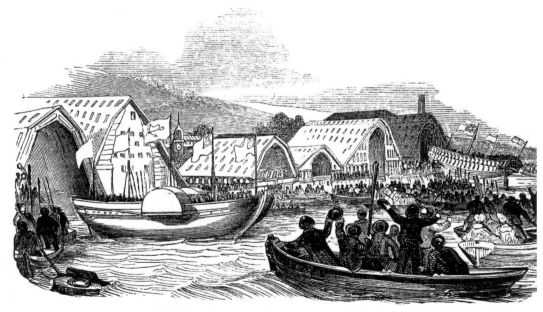

CHATHAM DOCKYARD—LAUNCH OF THE GOLIATH AND THE VIRAGO.

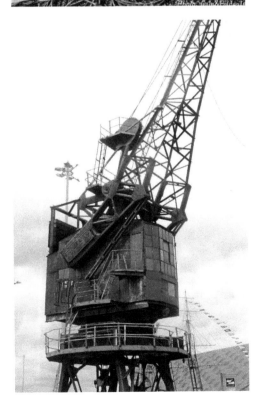
Photo: John & Gabriele

Dockyard Cranes

An important feature of the naval dockyard at Chatham has always been the extensive use of cranes, the heaviest most often positioned around the dry docks for the purpose of lifting heavy machinery into and out of a ship undergoing repairs. The earlier photograph shows a 160-ton crane positioned over the battleship *Hood* sometime around 1903.

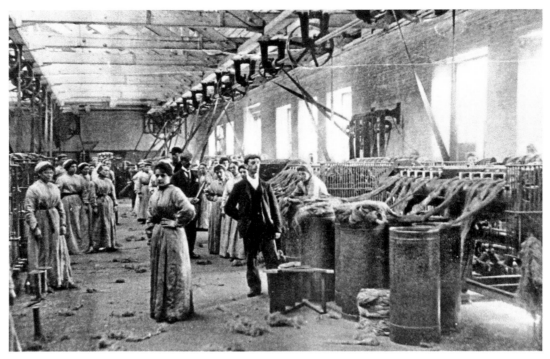

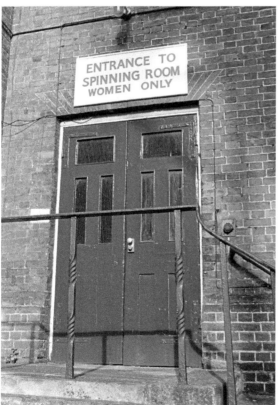

Spinning Floor

Although women worked in most areas of the dockyard during the two world wars, this proved, up until the later years of the twentieth century, a fairly exceptional occurrence. Instead, the employment of women had been mainly restricted to the spinning room of the ropery and the colour loft. This had been allowed from the mid-nineteenth century onwards, with the Admiralty imposing a number of strict rules that included women having a separate entrance when working alongside men and having hours of work that permitted them to enter and leave the yard at different times to that of men. Here, women are seen employed on the spinning floor of the ropery in 1902 while the sign designating their separate entrance point has been restored and returned to its original location.

The Colour Loft

The manufacture of ships' flags (or colours) was undertaken by the women of the colour loft, a building situated close to the Main Gate. Sewing machines were manually powered until replaced by electric Singer machines in later years. Almost certainly, the flags displayed on Nelson's *Victory* prior to the Battle of Trafalgar were manufactured in the dockyard, that vessel having undergone a refit at Chatham prior to the battle. While *Victory* is a Chatham built ship (launched in 1765) and exhibited at Portsmouth, this fascinating model, made for the Alexander Korda film, *That Hamilton Woman* is now on display at the dockyard museum.

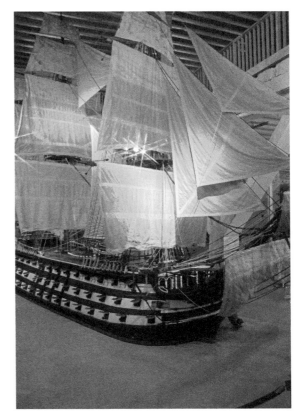

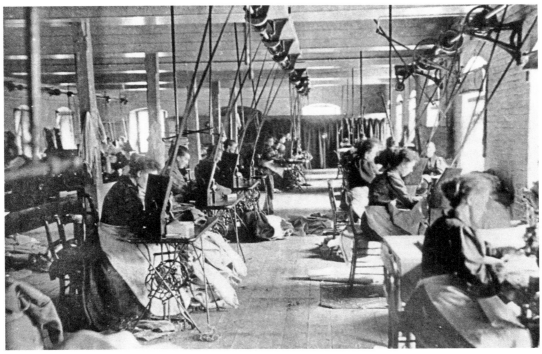

No. 1 Smithery

Constructed between 1806 and 1808 to a design of Edward Holl, the Navy Board architect, the Smithery, for many years following the closure of the dockyard, remained abandoned and neglected. The earlier photograph shows how the Smithery looked just a few years after the yard's closure while the accompanying photograph shows the outside of the building shortly after it had been opened as an exhibition centre.

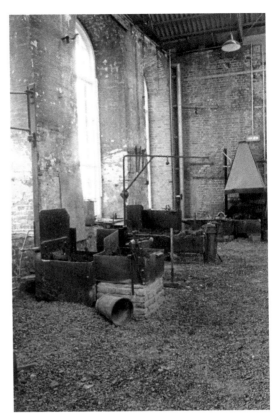

New Smithery

Among features retained in the new Smithery following its opening to the public are some of the forges once used for the manufacture of anchors. With air pumped onto the coals to increase the temperature of the forge furnace fires, the temperature inside the building (especially in summer) must have been quite unbearable.

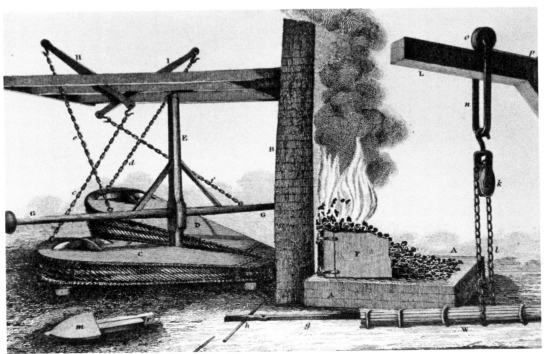

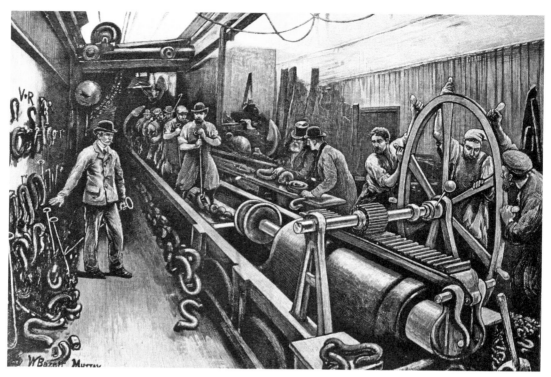

Chain Testing House

Situated between the ropery and the rigging house on the anchor wharf, the Chain Testing House was used to test the strength of anchor chains to ensure they stood up to the pressures that would later be placed on them. A similar process was also carried out for rope, with the modern photograph showing the entry door to the Rope Testing House.

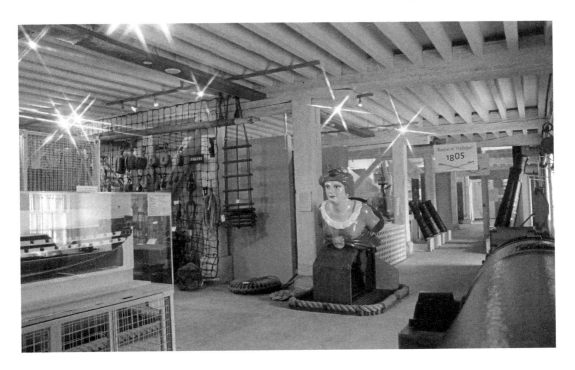

The Dockyard Museums

The original Chatham Dockyard Museum, which was probably created towards the end of the nineteenth century, was located within an unidentified building in the older part of the yard. The current museum is located in Block B of the Rigging House and which is located alongside the Anchor Wharf.

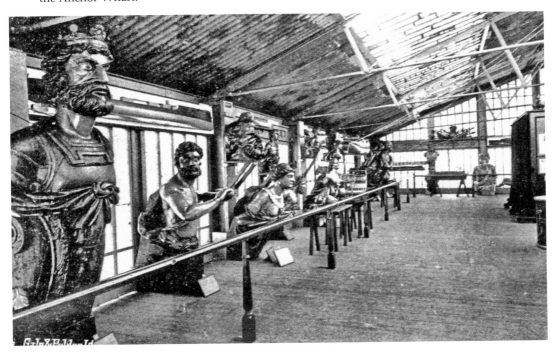

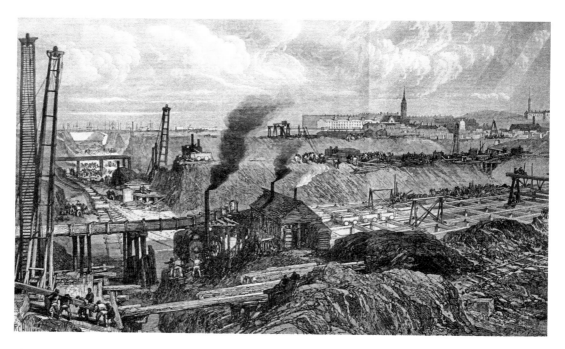

The Repairing Basin

Planned in 1865 and under construction by 1868, the Repairing (or No. 1) Basin was just over 20 acres in size and was part of a massive 300-acre extension to the existing yard. Beyond the building works, and where the Navy Barracks was subsequently built, can be seen the convict prison that supplied much of the workforce. The modern view of the Repairing Basin shows that a few of the original buildings have been retained.

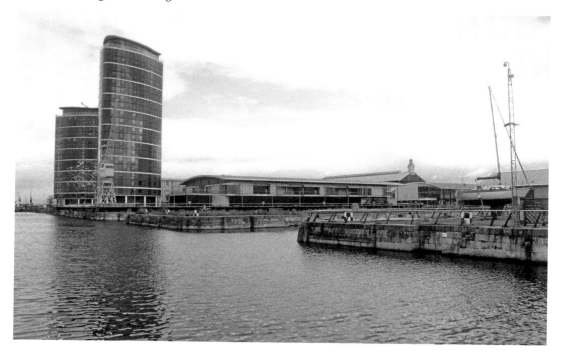

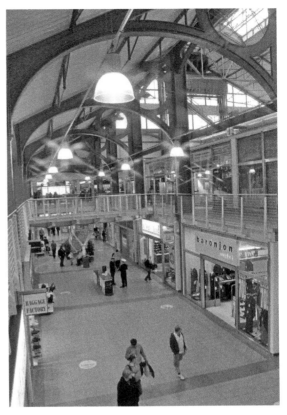

Dockside

By 1871 the Repairing Basin and its
three docks was substantially complete,
although caissons (floating dock gates)
are still needed for the two nearest
docks (Nos. 5 and 6). One building that
was eventually to be positioned on
the vacant land to the south is that of
Boiler Shop No. 1. In its own right, this
particular building has an interesting
history, having begun life as the
covering for a building slip at Woolwich
dockyard. Following the closure of the
latter yard in 1869, the building was
brought, frame by frame, to Chatham
where it now survives as Dockside, an
enclosed shopping centre.

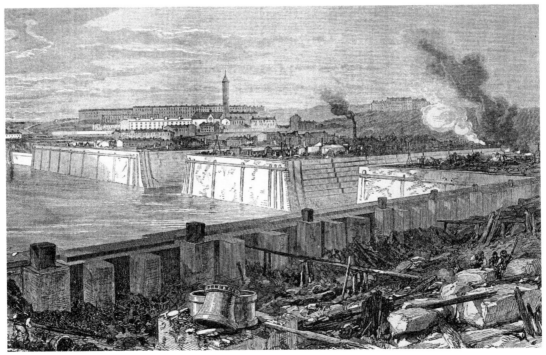

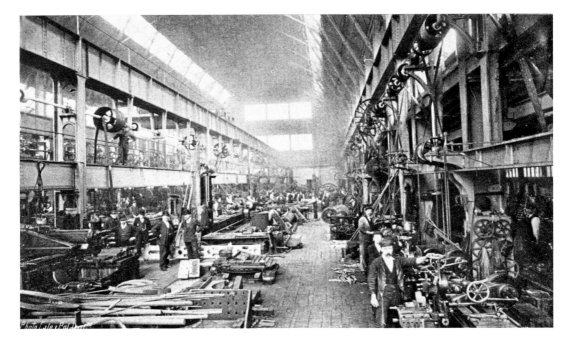

Ship Fitters' Shop/*Dickens World*

The much-vaunted *Dickens World* stands on the approximate site of a once important industrial building, the Ship Fitters' Shop. Those who once worked within the building were responsible for work carried out on the auxiliary machinery of warships, including steering gear, winches, windlasses, valves and rudders. That *Dickens World* should be brought to the area of the former dockyard builds on the link that the famous novelist has with the yard, as his father employed at Chatham Dockyard as a pay clerk.

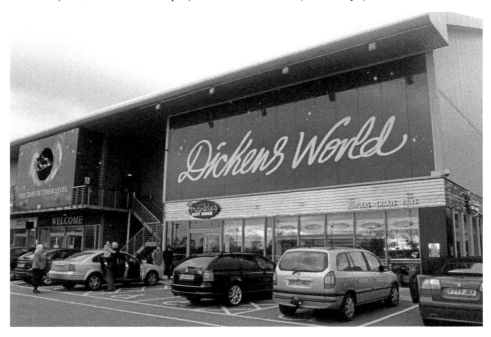

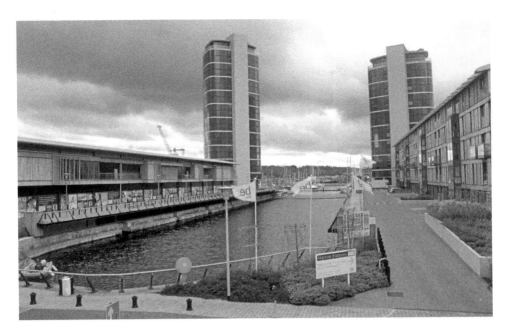

No. 7 Dock
Just over 426ft in length, the No. 7 Dock was one of four docks built on the south side of the Repairing Basin. Built by convicts, such as those depicted who may well have worked on this very dock, it is still an important feature of the dockyard, while being overlooked by residential flats.

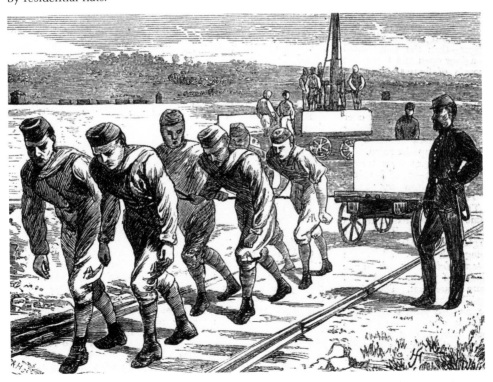

Pump House No. 5

Pump House No. 5 is a further building constructed by the convicts held in the prison building that adjoined the dockyard. Completed in 1874 it was designed to pump out water from the four dry docks that lined the south side of the Repairing Basin. A handsome red brick building of 77ft in length, it once contained nine boilers that were connected to a series of 200hp pump engines. It is now a Grade II listed building and has been refurbished by the South East England Development Agency (SEEDA).

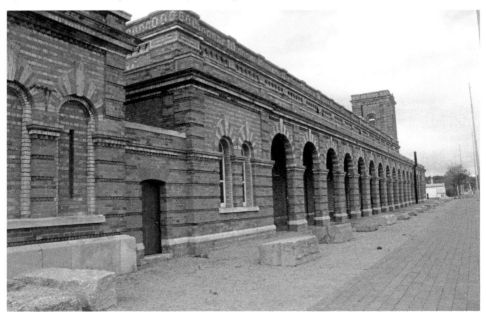

Machine Shop No. 8

Situated alongside the former No. 8 Dock, the Machine Shop was a further building brought to the yard from Woolwich, re-erected at Chatham in 1875. Although originally clad in corrugated sheeting, this suffered substantial storm damage in October 1987 and had to be removed with only the frame of the building retained. It is now a Grade II listed building. Following her return from the Falklands in 1982, HMS *Endurance*, a survey ship that played a vital role in the conflict with Argentina, was immediately placed into the No. 8 Dock where some of the work undertaken upon her was carried out by those employed in the No. 8 Machine Shop.

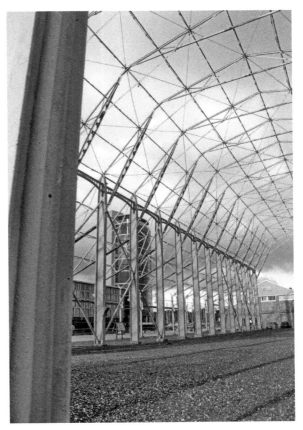

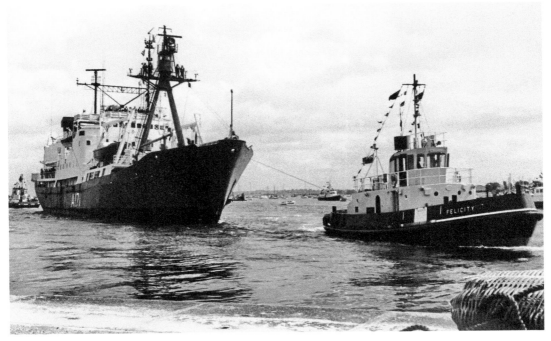

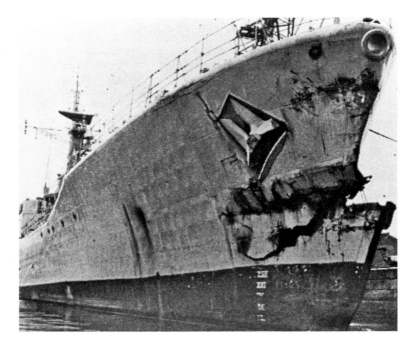

Visiting Ships

At one time the basins of the dockyard played an important role in the repair and maintenance of warships. In all, there were three basins built during the late nineteenth century, these respectively known as the Fitting Out Basin (the most easterly and largest), the Factory Basin (situated in the middle) and the Repairing Basin. Most commonly, maritime craft to be found in the Repairing Basin are usually pleasure craft, although a small collection of historic vessels (owned by the South Eastern Tug Society) is also held in the basin. An earlier visitor to the same basin was the frigate, HMS *Yarmouth*, severely damaged during the Icelandic Cod Wars.

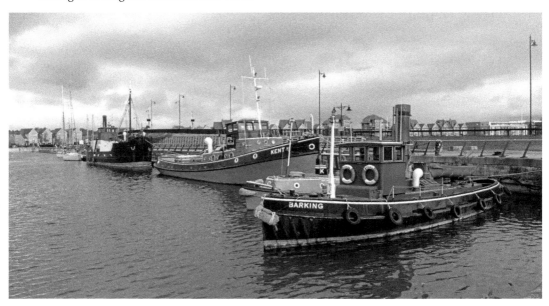